THE McGLINCY
KILLINGS

in

CAMPBELL
CALIFORNIA

AN 1896 UNSOLVED MYSTERY

TOBIN GILMAN

THE
History
PRESS

Published by The History Press
Charleston, SC
www.historypress.net

Cover images: Front cover top row and top photo, as well as inset on back, courtesy Campbell Historical Museum. Front cover bottom photo and back cover bottom photo courtesy History San Jose.

First published 2018

Manufactured in the United States

ISBN 9781467138437

Library of Congress Control Number: 2017955897

Notice: The information in this book is true and complete to the best of our knowledge. It is offered without guarantee on the part of the author or The History Press. The author and The History Press disclaim all liability in connection with the use of this book.

CONTENTS

Acknowledgements 5

Innocence Lost in Santa Clara County 7
Profile of a Psychopath 32
Manhunt 47
An Inconclusive End to a Century 74
Mistaken Identities 85
Bounty Hunters, Tipsters and Scammers 91
William Hatfield Goes to Jail 100
Hope Fades 112

Aftermath 115
Bibliography 123
Index 125
About the Author 128

ACKNOWLEDGEMENTS

I n 2013, I attended a talk hosted by the California Pioneers of Santa Clara County and delivered by Santa Clara County Superior Court judge Paul Bernal. Judge Bernal's talk, entitled "The McGlincy Massacre," vividly recounted the people, places and events associated with the infamous Campbell mass murder of 1896 and inspired me to write this book.

History San Jose assisted me in securing images for the book, and I'm especially grateful to Cate Mills, who uncovered rare crime scene photos from the HSJ digital archives. Anna Rosenbluth and Kerry Perkins of the Campbell Historical Museum provided invaluable assistance and support in my research of turn-of-the-century Campbell history and in securing historic images of the town where the crime occurred. Likewise, Erin Herzog of the San Jose Public Library California Room was amazing in helping me navigate the library's vast archives and securing rare historic photos of the Santa Clara Valley.

Georgia Wade, a longtime San Jose resident who grew up in the east foothills of San Jose, where the killer initially fled, read the first draft of my manuscript and gave me the encouragement I desperately needed to continue with the project. Pete Shivers, a volunteer docent colleague of mine at the New Almaden Quicksilver Mining Museum, read a later version of the manuscript and provided detailed edits, comments and suggestions that profoundly improved the flow and clarity of the book. Sprint car racing legend Howard Kaeding, a resident of Campbell since 1938, was raised near the McGlincy property and had a childhood friend who lived in the home

where the murders occurred. Howard was kind enough to spend several hours sharing memories and showing me exactly where the McGlincy home had been located prior to its demolition in the 1950s.

Finally, special thanks to our family dogs, Keiki and Goose. Those boys were with me through thick and thin, every step of the way.

INNOCENCE LOST IN SANTA CLARA COUNTY

THE ORCHARD CITY

The township of Campbell, California, nestled in the Santa Clara Valley and adjoining the city of San Jose, was bustling in the spring of 1896. More than twenty years had passed since Benjamin and Mary Campbell, along with other ranchers, had granted the South Pacific Coast Railroad a right-of-way through their land to facilitate the transport of locally grown agricultural products to consumers back east. Following the construction of a small depot a decade earlier called Campbell Station, the Campbells started to subdivide their 160-acre ranch, eventually forming downtown Campbell. The township, largely settled by prosperous easterners, had the distinction of being the only community in Santa Clara County under prohibition.

By the 1890s, Campbell had become known as "Orchard City." Many local orchardists began banding together in cooperatives, the most notable of which was the Campbell Fruit Growers Union, formed in 1892. The convenience of rail transport provided a strong incentive for major canneries and fruit drying ventures to locate by the tracks, with the Ainsley and Hyde canneries emerging as centers for packing and shipping fruit. To serve the hundreds of workers employed in the fruit orchards and canneries, churches and grocery stores opened, and in 1895, the Bank of Campbell was established.

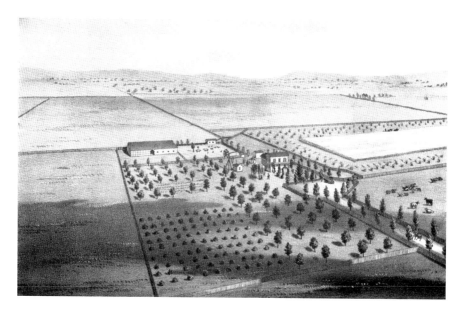

Ben and Mary Campbell orchard and residence, circa 1876. *Courtesy History San Jose.*

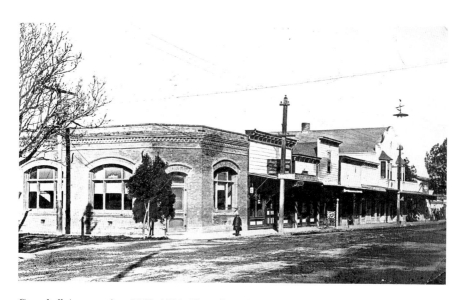

Campbell Avenue, circa 1900–1910. Photo from the *Campbell Weekly News. Courtesy Campbell Historical Museum.*

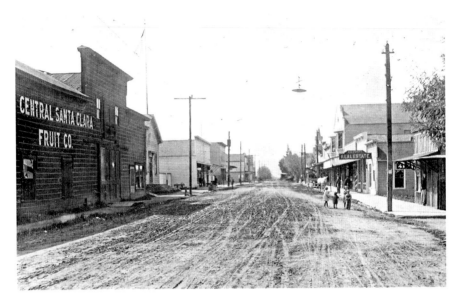

Campbell Avenue looking west, circa 1900–1910. On the left is the Central Santa Clara Fruit Company. Photo from the *Campbell Weekly News*. *Courtesy Campbell Historical Museum.*

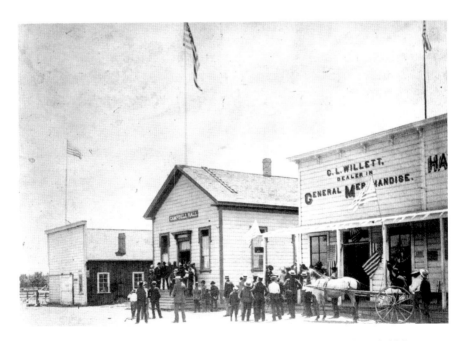

Willetts Store in downtown Campbell, circa 1889–94. *Courtesy Campbell Historical Museum.*

Campbell Avenue, circa 1889–94. *Courtesy Campbell Historical Museum.*

May 26 was a typical day in Campbell. The *San Jose Evening News* was brimming with attention-grabbing stories of local interest:

- A spiritual medium and self-proclaimed "psychographist" named Fred Evens testified in a local court case about how he helped the dead communicate with the living using two slates and a piece of pencil lead.
- A San Jose resident named Fred A. Misippo was granted citizenship.
- The trustees of the Agnews State Hospital were under fire for placing advertisements that called their political leanings into question.
- The Christian Endeavor and the Epworth League Society met and agreed to help raise funds for the YMCA.
- The low price of horses, caused by over-breeding and the growing popularity of bicycles, was resulting in many unwanted animals being sent to the slaughterhouse, where they were killed, canned and sold as food.
- Dairy Inspector Spencer was keeping busy examining cows throughout the county. A day earlier, he had killed a cow in east

Nineteenth-century cherry pickers on a ranch in Campbell. In 1893, Campbell canner J.C. Ainsley began marketing a product called "fruit salad" under the "Golden Morn" label. *Courtesy Campbell Historical Museum.*

San Jose, and an autopsy was performed confirming tests of the cow's milk indicating the animal had been sick.

- During the previous week, 72,000 pounds of cherries, 184,770 pounds of dried prunes, 167,830 pounds of wine, 24,150 pounds of grape juice and 49,050 pounds of hops had been shipped back east.

No one in Santa Clara County reading the newspaper that day could have foreseen the shocking story that would appear on the front page of the local and national papers the following day.

A Crime Is Reported

It was after midnight on May 27 when thirty-nine-year-old Santa Clara county sheriff James Lyndon received word that he was about to be tasked with solving not only the biggest crime of his career but also the most heinous crime in Santa Clara County history. Six people had just been found violently

murdered at the ranch of one of the county's most prominent citizens. The killer was armed and on the loose.

The murderer was thirty-one-year-old James Dunham. The victims included Dunham's father-in-law, Colonel Richard P. McGlincy, fifty-six; Mrs. Ada Wells McGlincy, fifty-three, the colonel's second wife and mother-in-law to Dunham; Mrs. Hattie Wells Dunham, twenty-five, the colonel's stepdaughter and wife of the killer; James K. Wells, twenty-two, Dunham's brother-in-law and the colonel's stepson; Minnie Shesler, twenty-eight, a domestic servant; and Robert Brisco, fifty, a ranch hand. The sole survivors on the property that night were Dunham's infant son, Percy, who was born just three weeks earlier on May 4, and a ranch hand who managed to elude the killer.

Neighbors who reported the crime had rushed to the McGlincy residence after the sound of gunshots had broken the still silence of night. Upon arrival, they encountered the body of Colonel McGlincy in the yard, lying in a pool of blood. Inside the home, they found more bodies, evidence of unspeakable violence and, amid the carnage, a tiny baby sleeping peacefully. Arriving too late to save any of the victims, Lyndon notified authorities in San Jose.

Lyndon was well acquainted with Colonel McGlincy. In many ways, the colonel, who was seventeen years his senior, had lived a life that paralleled his own. Both men were military veterans who were born in the East and moved west to Santa Clara County, where they became successful businessmen and active in local politics. Born in Jefferson County, West Virginia, in 1841, McGlincy began his career at the age of eleven, working as an errand boy in the printing office of his hometown paper. As a young man, he served with distinction in the Civil War, fighting under Stonewall Jackson and rising to the rank of colonel. After the war, McGlincy returned to the paper, holding the position of office foreman.

In 1868, the colonel married and moved to Illinois, eventually becoming dairy editor with the *Elgin Gazette*, as well as for a Minneapolis newspaper. It was in Elgin that his passion for the newspaper business and the dairy industry converged. By the 1870s, he had been named city editor of the *Elgin Advocate*, was secretary of the Northwestern Dairymen's Association and was an Odd Fellow of good standing. He was known to deliver addresses at dairy industry gatherings on relevant topics of the trade, including "Butter Making on the Farm," "Dairy vs. Grain Farming" and "Hints and Helps in Dairying." In 1880, he was elected secretary of the Elgin Board of Trade and served as one of forty-seven delegates at the Democratic Congressional

Convention that was held in Elgin. Evidence of the colonel's integrity and selfless character is reflected in an 1885 Illinois state auditor's report that noted McGlincy had not claimed $30.70 owed to him for expenses incurred as a witness representing the Elgin dairymen before a state legislative committee.

As his career flourished, his marriage floundered. In 1887, the prominent dairy expert and agricultural writer's wife filed for divorce, alleging cruelty and infidelity. In the fall of that year, the colonel moved to San Jose, possibly seeking escape from what might have

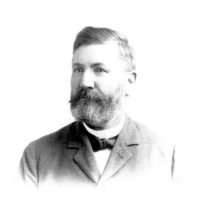

Portrait of Colonel Richard P. McGlincy. *Courtesy Campbell Historical Museum.*

been unpleasant memories of his marriage and perhaps also motivated by Santa Clara County's burgeoning agricultural industry, beautiful landscape and sunny weather. Whatever the reasons, by 1889 his divorce was final and he was thriving in California.

By the 1890s, he had established himself in horticulture, serving as an elected officer of the Campbell Horticulturists and a member of the Grape Growers Protective Association of Santa Clara Valley. In the summer of 1893, Colonel McGlincy drew attention to his exhibit at the World's Fair in Chicago by unveiling a "prancing prune horse," a wooden horse adorned with dried prunes, apricots, apples, raisins and other agricultural products from the county. When the fair ended, a newspaper article reported that he had lost his railway ticket home and suggested, tongue-in-cheek, that it would be an excellent advertisement for Santa Clara County if he rode the prune horse home.

At the same time, the colonel was becoming active in local politics. In November 1892, he spoke to the First Ward Democratic Club, and in August 1894, he was championed by the Democratic County Committee to represent local Democrats at the State Democratic Convention, which was to convene in San Francisco later that month.

The rejuvenation of the colonel's professional life in California was accompanied by a rejuvenation of his personal and romantic life when he met and married Ada Marie Kendall Wells, a widow and mother of three. The couple, along with two of Ada's grown children from her first marriage,

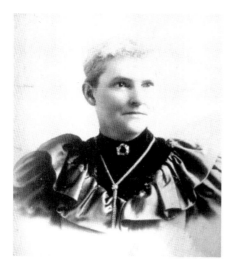
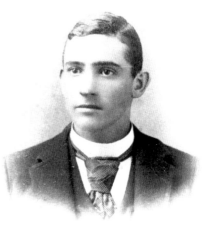

Left: Portrait of Ada Wells McGlincy. *Courtesy Campbell Historical Museum.*

Right: Portrait of James "Jimmy" Wells. A week and a half before the crime, he injured himself in a tandem bicycle accident. *Courtesy Campbell Historical Museum.*

Harriet "Hattie" Wells and James "Jimmy" Wells, settled into a stately home on the McGlincy ranch.

The expansive home and property proved fortuitous, as the new family soon expanded. Hattie married a local man named James Dunham, who moved into the residence. In short order, the couple welcomed a baby boy into the world, and a domestic servant, Minnie Shesler, was hired to assist with the infant's care. From outward appearances, the family patriarch was blessed with community admiration, a comfortable home and a happy family.

While the citizens of Santa Clara County slept, blissfully unaware of the news that would shock them to the core in the hours ahead, the sheriff hastily grabbed his coat, holstered his gun, saddled his horse and went to work.

THE CRIME SCENE

It was around 1:00 a.m. when Sheriff Lyndon met Deputy Sheriffs Black and Gardner at the crime scene. A full moon illuminated a stately, white, two-story house featuring bay windows on every side. Across from what earlier that evening had been transformed into a house of horrors stood

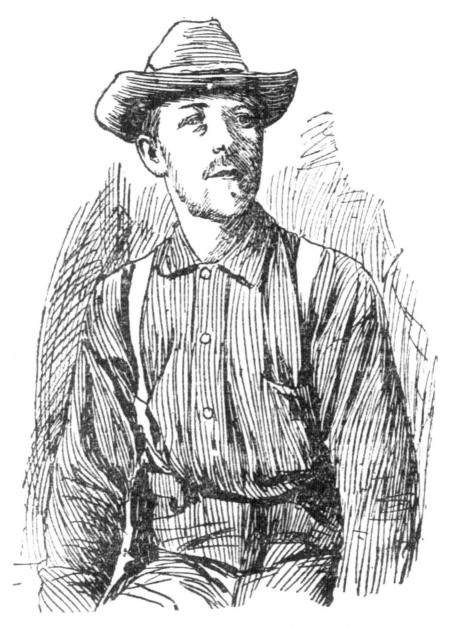

Artist's rendering of George Schaeble. Published in the *San Francisco Call*, May 29, 1896.

a large barn and a bunk house, surrounded by a fifty-four-acre orchard that comprised the colonel's estate. A cacophony of chirping crickets and croaking frogs augmented the animated conversations among bathrobe-clad neighbors, police officers and newsmen gathered at the ranch.

The bodies of McGlincy and Brisco had been taken inside and placed beside the bullet-ridden body of James Wells in the front room where he met his death. Pending an inquest by County Coroner Secord, the body of Mrs. McGlincy was left undisturbed in the downstairs bedroom where she was killed, as were the bodies of Hattie and Minnie, who were killed in Mrs. Dunham's upstairs bedroom.

The first eyewitness Lyndon interviewed was George Schaeble, a ranch hand and intended victim. Schaeble had been hiding in a loft in the barn after hearing gunfire and peered out a window as Dunham shot the colonel and Robert Brisco in the yard below. In a voice still quivering from shock and fear, Schaeble recounted the sequence of events that nearly cost him his life.

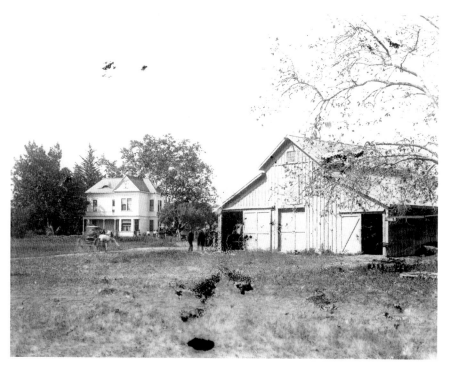

The McGlincy ranch in 1896. The house where most of the murders were committed is on the left. A horse and carriage wait outside the house. The house was demolished in 1955. *Courtesy History San Jose.*

Lyndon then interviewed a second witness. A neighbor, L.C. Ross, had been awakened by gunfire and observed the latter stages of the crime from a vantage point behind the barn. Ross noted that Dunham took a horse from the barn and hastily rode off without bothering to saddle the animal.

As Lyndon surveyed the scene, questions were racing through his mind. The facts presented to him by witnesses established beyond any doubt that James Dunham was the sole killer. But what could have possibly motivated him? Had an argument escalated into a spontaneous act of rage? Or was it a carefully calculated, premeditated murder? Why was the baby left unharmed? And most importantly, where was Dunham?

Charles Sterret reported that he had just seen Dunham on a horse at the intersection of Campbell Avenue and the Los Gatos Road. He had been walking home along Campbell Avenue shortly before midnight when he heard someone say there was trouble at the McGlincy home. Moments later, he heard the sound of a horse trotting down the San Jose Road. Thinking it may be someone who could share more information, he ran to the corner and shouted, "Who are you?"

The stranger brought his horse to a stop, turned it around and replied with a question of his own: "Did you see George?"

"No" answered Sterret.

The stranger then asked, "Did you see a man on horseback?" This time, Sterret replied in the affirmative. "What color was his horse?"

"Bay. Who are you?" The stranger pulled his hand up from his side, which led Sterret to suspect he was wielding a pistol. "Who are you? What is your name?"

Sterret told the stranger that he was staying at the Koch ranch and then asked, "What is the matter at McGlincy's?"

"Who is McGlincy? Where does he live? I don't know McGlincy." The stranger's curious behavior aroused the young man's suspicions, and he continued to ask more questions. Dunham abruptly drew his revolver and rode off at a rapid gait on the Infirmary Road to Campbell Avenue and then turned and went south. Sterret immediately went to the McGlincy ranch and reported the incident. He was positive the man he'd just encountered was Dunham and was equally certain that Dunham did not know who he was.

Sterret told authorities that the horse Dunham had been riding was saddled. Since Ross said Dunham rode away from the ranch bareback, police wondered if Dunham had secured a saddle at some point after leaving the ranch and before arriving at the intersection. Evidence found

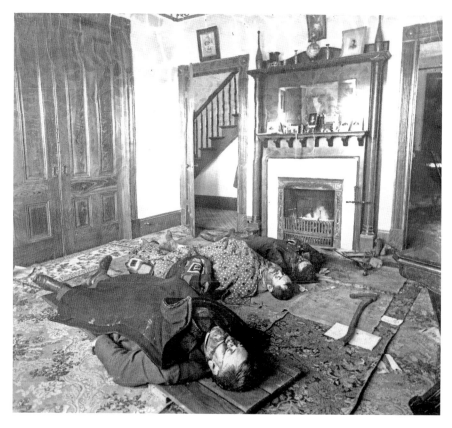

Above: The bodies of Colonel McGlincy and Robert Brisco were brought inside and laid next to the body of Jimmy Wells downstairs. *Courtesy History San Jose.*

Opposite, top: This crime scene photo is believed to be taken in the upstairs bedroom where Hattie Dunham and Minnie Shesler were savagely murdered. *Courtesy History San Jose.*

Opposite, bottom: This photo is believed to be taken in the downstairs bedroom where Mrs. McGlincy was killed. *Courtesy History San Jose.*

later in the search for Dunham led investigators to conclude that Sterret must have been mistaken on this point.

Before the sun came up, authorities throughout Santa Clara County and adjoining counties were notified by telegraph to be on the lookout for Dunham. Lyndon wanted to be sure that every possible escape outlet was sealed. While Lyndon and his men were gathering facts, journalists from the San Jose and San Francisco papers were at work, too, chasing the Bay Area's crime story of the century.

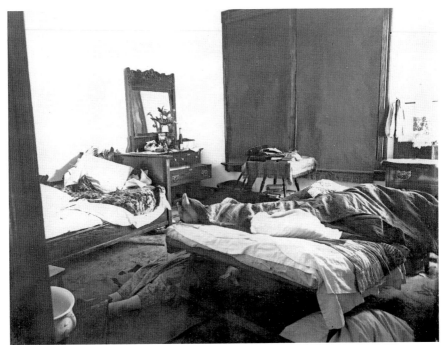

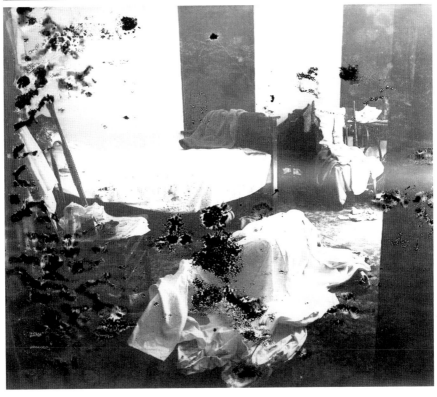

The *San Francisco Call*, which a year before the crime had been purchased by real estate and railway mogul John D. Spreckels, assigned an ambitious and exceptionally creative young journalist to cover the story. Perhaps inspired by another *Call* writer who was employed by the paper in 1863 and 1864 and later became known as Mark Twain, the reporter's account, published the very next day, screamed with vivid gore and represented the epitome of nineteenth-century sensationalism:

Slain with Ax and Pistol,
Colonel McGlincy, His Wife, Son and Daughter and Two Servants Murdered at Campbell

Horrid Deed of Butchery

In Gory Revel, James C. Dunham Gluts His Savage Passion—Death Struggles with a Demon

San Jose, Cal., May 27—Santa Clara County has hitherto stood aloof and read with shuddering wonder the stories of murder and blood and crime that came to her from distances that robbed them of much of their realism. The slaughter of the family and servants of Colonel R.P. McGlincy, six miles south of this place, at an early hour this morning, places a bloody page in her own history as horrible as any she has read.

The murders committed by James Dunham, 30 years of age, a son-in-law of Colonel, wipes most out of existence one of the most prominent families in the country. All that is left of the line is a baby, son of the murderer.

No discernable motive explains the awful crime. The man was not in high esteem with Colonel, and there had been quarrels between husband and wife, but the young man was being well taken care of, being allowed to attend school, to lead an easy life, with a certainty of being well-cared for to the end.

Madness alone explains it, but all who know him have hitherto rated him as very sane. The characteristic that has been noted in him chiefly was meanness, penuriosness. The woman who stood by the bedside of his wife during the time that the child was born and afterward, said he was one of the very meanest—too mean to be crazy, she says.

The little two-months-old [sic] baby whom the murderer left lying asleep by the side of the mother he had strangled, and who has survived

in the sea of blood, will now fall heir to the McGlincy estate, one of the handsomest tracts in the country. There are some who make the guess that it was all done to that end. But unless he grows to be a man of his father's own ghastly kind he will never consider himself rich with this legacy.

The story of the crime is one that the reader might turn away from with horror and disbelief, save that he has been educated to credit such things through the series of crimes that have marked the later months and years. The victims were the murderer's wife, who was Colonel McGlincy's stepdaughter; Mrs. McGlincy; James K. Wells, a son of Mrs. McGlincy; Robert Brisco, a hired man; Minnie Shesler, a domestic, and the Colonel.

Colonel McGlincy, a young Wells, and George Schaeble, a hired man, left home early in the evening to attend a meeting of the American Protective Association at Campbell. What transpired after they left the house can only be conjectured by the scene that was presented at the house upon the arrival of the officers. It is supposed that Dunham waited until those of the family who remained at home were about to retire and had gone to their respective apartments. Then he went to his wife's room on the upper floor and strangled her while she lay upon a cot, still ill from her confinement, and with her baby beside her.

No, she was not strangled; but the mark of his fingers are upon her neck, her mouth was filled with clothes forced into it and her neck was dislocated. He had used her with such maniac force as to break her neck by twisting her head to one side.

The murderer began with the purpose that he carried out, of killing all, for he had armed himself.

Minnie Shesler, the domestic, was preparing for bed in the adjoining room. She heard the confused noise, and slipping on her dress, taking only time to fasten the single button at the neck, she ran into the room and was felled as she crossed the threshold by the blow of an ax. She made no cry, for she scarcely knew what was happening. The fiend struck her again and again with the edge of the ax, then turned it and crushed her skull with several blows of the blunt end. In his frenzy he also jammed some clothes into her throat and threw her body alongside the cot where lay his wife.

Then the fiend went downstairs to the room of old Mrs. McGlincy. She was evidently up and about to inquire into the strange noises overhead. He used the ax here also. The old woman was struck one blow with the edge of the ax and then the weapon was turned and her skull completely crushed with a half a dozen blows from the blunt end.

Save for the baby that slept upstairs the havoc was complete. The murderer now ransacked the house for his own effects, gathering together his letters and photographs of himself, by which, in taking them with him in his intended flight, he hoped perhaps to make identification difficult.

But his work was not done. He had yet to kill Colonel McGlincy and his stepson, Jimmy Wells, who, unconscious of the tragedy going forward in their own home, were taking part in the American Protective Association meeting at Campbell, a mile and a half away.

It is supposed that Dunham killed the three women at 10 o'clock at night. It was after 12 o'clock when Colonel McGlincy and Jimmy Wells and the hired man, George Schaeble, returned home. During those two hours the murderer waited in the charnel house. In this charnel house, the bodies of his victim, lying in his way, did he attempt to move about, listening to the drip, drip, drip of the blood of his wife and of Minnie Shesler as it percolated through the crevices of the floor above and mingled with that of the old woman downstairs? Did he gaze upon the slow spread of crimson over the carpet, and the white, distorted faces of the three dead women? For it was not so dark, the full moon illuminating the rooms.

There was sleeping in a little shanty a hundred yards from the house a hired man, Robert Brisco. He lay there all that time, also unconscious of the doom that was waiting him. It may not have been the purpose of Dunham to kill this man. If the guesses as to the motive of the crime, that Dunham did this thing to leave his little boy this bloody heritage, be correct, then he probably did not. He became a national victim of the incidents of the second chapter of the story of slaughter.

As Colonel McGlincy and Wells and Schaeble approached the house on the road from town they passed the shanty where Brisco slept and the barn which is near it. McGlincy told Schaeble to open the barn, as it must have been very hot in there, and throw down some hay. That order saved young Schaeble's life. He opened the barn, and then went around back of it to open a window there. As he did so he heard several shots fired from within the McGlincy house. The murderer had resumed his work.

Colonel McGlincy opened his front door with a latch-key. As he stepped into the dark hall he was struck on the side of the head with that terrible ax and fell to the floor. Young Jimmy Wells was just behind him, and before the murderer could raise his weapon again he grappled with him.

Then Dunham fell back upon the resources he had provided for such an emergency, and, dropping his ax, drew a revolver. A short but terrific fight followed, the witnesses of which are broken furniture, a guitar crushed to

fragments, torn clothes and blood over everything, a track leading through the hall and two rooms, at the end of which the body of Jimmy Wells was found with five bullets, one passing clear through and into the floor. He died hard, but there was no doubt that he was dead.

McGlincy had not been rendered insensible by the ax, for his hat had broken its force. He sprang to his feet and in his terror ran through the house and sprang through an open window in the rear, where marks of bloody fingers tell of it. He ran around the house, and Schaeble, standing in the rear of the barn, saw him running toward him, or rather toward the men's sleeping shanty. He was crying murder and calling for help. He had reached a point opposite the front of the barn when Schaeble saw Dunham leap out of the front door and follow after him, firing a revolver as he went.

McGlincy reached the shanty, however, sprang in and braced himself against the door. Dunham was at the door in an instant. As he ran Schaeble climbed through the rear window of the barn that he had just opened, and, mounting to the loft, saw through the open door all that followed. Dunham threw himself against the door of the shanty, but it remained firm.

"Come out, Mac," he said. "Come out; I want to see you."

There was no reply.

"Come out, Mac," said Dunham. "I am bound to have you anyhow. Bob, come out here; I want you, too," he continued, "and you, too, Schaeble."

He referred to Robert Brisco and to Schaeble, who was, unknown to him, watching from the barn. He was talking in a rapid but perfectly distinct and apparently not very excited manner. McGlincy answered him:

"I won't come out, Jim; I have two bullets in me now. Put up your revolver."

"Very well, I will. Now come out."

"No; I won't come out." said McGlincy.

Then Dunham placed the revolver to the cabin door and fired through a crevice. The powder marks are upon the door. He fired again through the door. At that, Robert Brisco, the hired man, sprang through the rear window and started to run along the fence. Dunham heard this and was after him in an instant.

He fired but two shots in quick succession, and both of them were true. Brisco fell by the fence with a bullet through his heart and another through both lungs. Both of them passed completely through the body. The murderer handled his revolver with as deadly effect as he had wielded his ax.

Colonel McGlincy took advantage of the diverted attention of the murderer, and opening the door of the cabin started again toward his own

house. He had made scarcely twenty paces when the man with the revolver was upon him and he fell with a ball in his heart.

With all this, the murderer's hot brain had not lost its ability to count. Everybody in sight upon the estate had fallen before him. But he remembered there was another. What had become of George Schaeble? He should have been in his cabin with Robert Brisco. So he went about the place calling:

"George! George Schaeble! Where are you George? I want you."

And George Schaeble, paralyzed with fear, stood in a loft of the barn and saw him through a crevice and heard him; saw the gleam of the long revolver in the moonlight; watched him circle the cabin; saw him stop as though pondering what to do; saw him go over to the body of Brisco at the fence, and while he stood there heard him say again: "George! George Schaeble! Where are you, George?" in that plain, even tone that he had often been called to across the fields. Then he saw him turn and come toward the barn and enter it. He climbed the ladder into the loft and standing on the hay struck a match. The light flared up and then died away.

The footsteps of the murderer were now upon the ladder going down again. He had not seen the crouching figure in the hay. And George Schaeble's hair did not turn gray in those three minutes!

Dunham took a horse, and without a saddle rode to the house, tied up and entered. He took the little package that he had gathered together, mounted the horse again and rode up and down the roads about the house, still looking, and once or twice calling for Schaeble. Then he turned his horse into the main road, and going at a good trot, disappeared.

The latter part of these proceedings were witnessed by others than George Schaeble. L.C. Ross, a neighbor, had heard the shots and, hurrying toward the McGlincy house, saw the siege of Dunham at the cabin and subsequent shooting of McGlincy and Brisco. He was without weapons and kept under the cover of the trees. When Dunham rode away Ross hurriedly summoned G.W. Page and G.A. Whipple, two other neighbors, and they entered the house.

On the porch they found the big 45-caliber revolver. They opened the door and were met by the smoke of a smoldering fire. It was the clothes on the body of Jimmy Wells that had taken fire from the powder of the revolver's discharge close against him. It had been a terrible fight, that with Jimmy Wells. Step by step they made the discovery of all the frightful slaughter of the household.

NATIONAL HEADLINES

Within two days, newspapers across the country picked up the story of a horrific crime in California. Headlines of the Victorian era were often verbose, dramatic and vividly descriptive.

Not content with terms like "assailant" or "perpetrator," many of the headlines assigned more visceral labels—"maniac," "madman," "the devil's own," "miscreant," "fiend" and "butcher" to name a few. "THE CRIME OF A MANIAC—Six Persons Killed by a Madman" was splashed across the front page of the *San Jose Mercury*. The headline in the *Adrian (MI) Daily Telegram* referred to murder as "THE DEVIL'S OWN—Surely Is the Miscreant that Has Done This Diabolism." The *Knoxville Daily Journal and Tribune* profiled the killer with this headline: "ARCH MURDER FIEND—Killed Eight People in a Brutal Manner in California." The succinct headline in the *Vansville (MD) Courier and Press* simply said "FIEND," followed with a subheading that read, "Californian Butchers His Wife and Five Others."

Other headlines described the crime itself. The *Fresno (CA) Morning Republican* almost blandly announced, "A FAMILY MURDERED—Terrible Crime in Santa Clara County." The *Jackson (MI) Citizen* led with "A HORRIBLE CRIME." The *Tacoma Daily News* was more specific, reporting "A HORRIBLE MURDER."

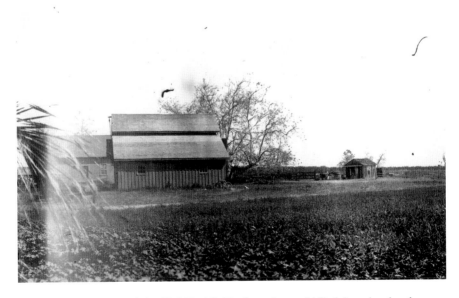

The barn where George Schaeble hid while Dunham shot and killed the colonel and Robert Brisco. *Courtesy History San Jose.*

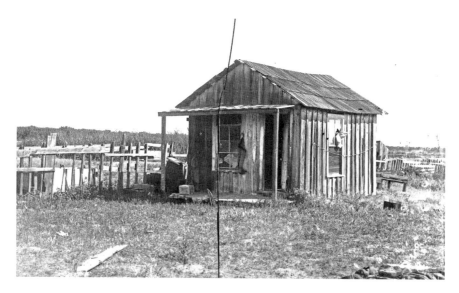

The bunkhouse where Robert Brisco was sleeping when Dunham's murderous rampage began. *Courtesy History San Jose.*

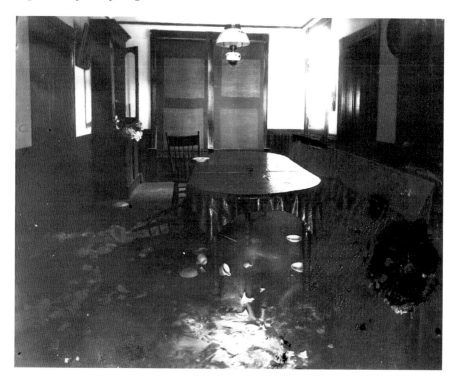

Crime scene photo of the downstairs room where Jimmy Wells put up a valiant fight. *Courtesy History San Jose.*

The headline of the Springfield, Massachusetts *Republican*, which said, "MURDERER SCORED SEVEN VICTIMS," might have been written by the sports editor. Other papers reported the "score" differently, if not accurately. According to the *San Diego Union*, "HE TOOK SIX LIVES." The *Omaha World Herald* decided to highlight the survivor rather than the victims with a headline that read, "KILLS ALL BUT THE BABY." A subheading noted, "California Man, While Insane, Murders Six in One House," even though, technically, two of the victims were killed outside the house.

The headlines in some papers were more reserved. According to the Boise, Idaho *Statesman*, the murder was a "CALIFORNIA TRAGEDY." The *Aberdeen (SD) Daily News* headline noted that "FAMILY TROUBLE" was said to have caused the murders.

A SHERIFF IN THE SPOTLIGHT RECALLS THE FATE OF A PREDECESSOR

Elected to office less than two years earlier, Lyndon felt as if all eyes in the county were on him. Three dimensions of the crime—the prominence and innocence of the victims, the merciless and violent brutality of the murders and the many mysteries surrounding motives and whereabouts of the killer—ensured that his handling of the case would be scrutinized in every detail.

Although he was relatively popular in the county, the slightest misstep could mean the end of his law enforcement career. Indeed, ten years earlier, the career of a beloved second-term sheriff named Ben Branham came to an abrupt end in the wake of a mishandled criminal prosecution of far less magnitude.

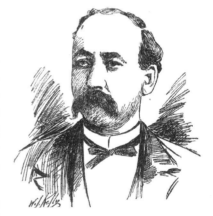

Artist's rendering of Santa Clara County sheriff Lyndon, published in the *San Francisco Call*, May 29, 1896.

Branham was first elected sheriff on the Democratic ticket in the November 1882 election, winning by a narrow majority of 764 votes. Public support grew during his first term, when he sent two well-known and widely despised murderers to the gallows.

Left: Sheriff Ben Branham's father, Isaac Branham, came to California in 1846 and established the first sawmill in Santa Clara County. *Courtesy History San Jose.*

Below: Hotel Lyndon, circa 1910. The hotel, owned by the sheriff's older brother, John, opened in 1899 and occupied 175 feet of frontage on Santa Cruz Avenue in Los Gatos. For sixty-four years, it held an important place in the cultural identity of the town. *Courtesy Campbell Historical Museum.*

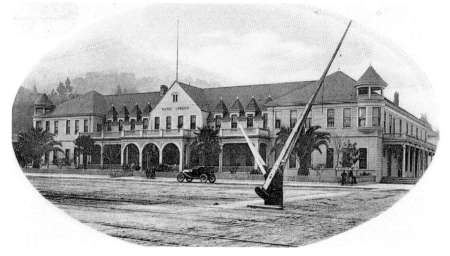

It was an event in 1886 that turned a large portion of the electorate against Branham and ultimately marked the end of his days as sheriff. An influential Mexican man by the name of Pedro Pacheco was charged and convicted of rape and was sentenced to twenty years in San Quentin State Prison. During the heated and politically charged trial, charges were hurled at the prosecution alleging that Pacheco had been framed and railroaded into prison.

After the trial, against his better judgment and in violation of the law, Branham succumbed to pressure to allow Pacheco to travel to Contra Costa County before starting his term in San Quentin. During the journey,

Pacheco, aided by a friend, escaped from the two deputy sheriffs who were escorting him. Public outrage erupted. Rumors circulated that Branham had deliberately allowed the escape to curry favor with the Mexican population and that the deputies had been bribed.

Sheriff Branham vowed to have Pacheco returned to the San Jose jail dead or alive and organized a posse to hunt him down. As it happened, Pacheco came back dead after a spectacular rifle duel. It took place in Tulare, where the sheriff and Pacheco spotted each other about one hundred yards apart. They shot it out on horseback, emptying six-shooters and rifles. Pacheco fell dead on his horse. When word of the killing filtered back to San Jose, the Mexican American community, many of whom were associated with the New Almaden mine, became outraged.

The *San Jose Evening News* rallied to shore up his political support ahead of the election, but the paper's effort proved insufficient. Just days before the election, the Mexican Americans of Santa Clara County held an "anti-Branham" meeting at the Promis' Hall on North Market Street. Inez Pacheco, a nephew of Pedro Pacheco, appeared before the gathering and beseeched the crowd to vote against Sheriff Branham. The nephew's appeal worked. Sheriff Branham suffered a narrow loss to Jonathan Sweigert. The final tally was 3,828 votes for Sweigert to 3,378 votes for Branham. Election observers speculated that Branham failed to garner a single Mexican vote.

Sorrow, Vengeance and Resolve

On May 28 at 1:30 p.m., the funeral of Minnie Shesler took place at the First Christian Church. Reverend B.B. Burton delivered the sermon to a packed church that included her parents, Dr. and Mrs. Shesler, friends and members of the Christian Endeavor Society and the Kate B. Sherwood Camp, Daughters of Veterans.

At 2:00 p.m. on May 29, five caskets encasing the bodies of the colonel, Mrs. McGlincy, Hattie, James Wells and Robert Brisco were lined up at the Congregational Church at Campbell. They were surrounded by an abundance of floral offerings unprecedented in Santa Clara County, contributed by friends and sympathizers from all over the valley. The Odd Fellows contributed a large floral pillow measuring five by eight feet, with these words of warning written in the center: "Vengeance Is Mine; You

Shall Repay, So Saith the Lord." Above it was a frame with the word "Rest," with three links suspended beneath it.

At 3:30 p.m., a solemn procession of hearses trailed by more than four hundred carriages made its way through San Jose, starting on Willow Street and working its way to Monterey Road destined for Oak Hill Cemetery. It was the largest body of mourners ever assembled in the county. A newspaper account described "miles of surreys, spring wagons, phaetons, hacks and carryalls, headed by six glass-encased hearses with white plumes at each corner."

On the morning of June 20, the San Jose Grange held a memorial service at the GAR Hall to honor the memory of the McGlincy family. A Mrs. Woodhams began with a message of hope: "We can hardly realize that our brothers and sisters are gone from us, yet we don't feel they have gone so far away. We can think of them as being just across the river where we can speak to them from heart to heart and voice to voice. As we gather here from week to week I believe we can be strengthened if we let our hearts go out and ask them to be with us."

Following a poem by a Mrs. Durkee, depicting the darkness and the sunshine in life and the power of the grace of God, Mrs. Woodhams's daughter sang a song. Reverend N.A. Haskell then spoke, at first providing divine context for the collective shock and sorrow that hung in the room:

I feel that I can hardly trust myself to speak under the emotion that is with us all, but I trust that what I will say is in harmony with you. The lives so suddenly terminated under such harrowing circumstances are gone and it is appalling. There is no adequate expression in the minds of the community in the hours of horrors, for such an event appalls our souls so that we go speechless.

Such a violence might as well have come to you or to me by the hand struck out in midnight darkness. How can such a disaster come to us in the light of faith and Providence? We may lose faith in man, still we know that God is in heaven and it is not a blind hope.

We believe life is not a chance for behind all is the unchangeable and the eternal. The lawless act of the criminal shocks our sensibilities. The hurt is too severe but could we see it in the light of God, the love could be seen and out of the mental confusion would come peace and joy.

The circumstances of the crime are only transitory. The brutal violence leaves no injury on the souls of our brothers and sisters; it mars them not, but it leaves a painful picture on our minds. Yet the glimpses of these great

and abiding truths calm somewhat our feelings. Through it all, however, we shudder at the act of bringing to an end these happy lives.

The reverend then offered a prescription for coping with the crime and preventing similar crimes in the future:

The criminal must be held accountable by man, nature and God. We cannot believe it possible for any one man to thwart the design of God. Judas murdered Christ and this criminal has murdered our brother, yet the divine plan is not frustrated. However wild the storm, we recognize that God is in heaven and ruled in the hearts of our departed friends.

There is no vindictive feeling against the criminal. If he comes into the power of the law, his punishment will be administered by the calm judgement of our people. The life of the criminal can in no way compensate for the lives of those he has taken, and if it were not for the community's security and the well-being of society, we would gladly let him vanish from our minds.

How shall we make it possible to prevent a recurrence of these horrors and establish the security of our families? Punish the criminal; make an example of him. Yet the causes that led to this crime lay in the murderer's ancestry.

The reverend closed with a call to reform the criminal justice system in order to prevent future crimes and the propagation of the criminal element in society. He advocated a change in prison discipline and the adoption of indeterminate sentencing—meaning an offender should be confined as long as he is deemed a criminal and beyond reform and redemption. The reverend also chastised the press for its demoralizing influence with its sensational details of the crime and lurid pictures.

PROFILE OF A PSYCHOPATH

The term *psychopath* did not find its way into the lexicon of American psychiatry and criminology until well into the twentieth century. If the label had existed in 1896, it would have fit James Dunham like a glove. Psychopaths possess little or no conscience. Killing and inflicting pain on others to achieve a desired goal, no matter how trivial, comes without remorse. They lack empathy toward others and are highly adept at displaying emotions they don't actually feel. Psychopaths can be charming, intelligent and manipulative. They are often drifters who avoid commitments in jobs, romance and friendships. Some researchers believe that psychopaths have physical brain defects that in some cases may be hereditary.

Interviews with acquaintances of Dunham conducted by law enforcement officers and reporters in the wake of the murders revealed indications of the killer's psychopathic tendencies that trace back at least to his early twenties.

About ten years before the murders, while temporarily employed on a nearby ranch, James would sometimes visit his mother's home in San Jose and pressure her for money using threats and intimidation. On one occasion, Mrs. Dunham stood her ground and denied his request. The young man simply glared at her and calmly walked out the door to the backyard. Moments later, the mother looked out a window and observed her son killing three of her chickens, "wringing their necks and tearing them to pieces."

James's marriage to Hattie Wells suggests that the callous disregard he held toward his mother at times was applied to his younger brother, Charles, as well. The loner, who had never experienced a committed relationship

prior to Hattie, met and courted his future wife even though she had recently been engaged to Charles. Amazingly and perhaps indicative of Dunham's manipulative charm, Charles remained loyal to his older sibling.

Whatever it was about the future killer that captivated Hattie's heart will never be fully understood. She was a graduate of the State Normal School in San Jose (later named San Jose State University) and was considered highly educated and refined by those who knew her. Charles Quincy, who had been close to Dunham since boyhood, voiced his opinion to local reporters: "I have every reason to believe that Hattie Wells married Jim just to spite Charley, his brother, with whom she had quarreled because Charley had went with another girl."

Hattie's friends felt that Dunham was far beneath her, noting that he was not personally attractive, did not dress or carry himself well, was lacking in career ambition and supported himself through odd jobs and contributed nothing toward his wife's support during their entire two-year marriage.

If Hattie thought that marriage would motivate James to settle down and commit to a stable, financially secure occupation, her hopes were quickly dashed. In the very early days of their marriage, James took Hattie to Stockton, where he engaged in selling bicycles while also operating a small fruit and vegetable store. The effort was financially unsuccessful, and the couple soon returned to the sanctuary of the McGlincy home. The Stockton business was just one of a string failed ventures. He also dabbled in a candy making enterprise, a nursery business in Chico and various enterprises in San Diego, Sacramento and other parts of the state.

Lack of business acumen was not the only flaw Hattie observed in her husband. While she and James were working at the state fair in Sacramento, Hattie noticed a watch and some other jewelry missing and reported it to the police. Within a matter of days, authorities traced the articles to a local pawnshop and determined that they had been brought there by Dunham. Confronted with the evidence by police, with Hattie in the room, Dunham confessed to the theft. No charges were filed.

Dunham's inability or unwillingness to earn a decent living was cushioned by a relatively generous inheritance he received upon the deaths of his parents. His mother had deeded to him a five-acre parcel on Foxworthy Road that he subsequently sold for $1,000. That nest egg was supplemented by cash proceeds he received from his father's property in Dulzera, a small community in San Diego County.

Despite his inheritance and the generosity of his father-in-law, James was unsatisfied with his financial status and was shameless in his efforts to improve

his lot. At one point, while working as a foreman for Colonel McGlincy on the fruit ranch, James fell from a ladder and suffered minor bruises. From that day forward, he threatened his father-in-law with a lawsuit seeking punitive damages of $10,000.

When threats failed to yield the reward Dunham sought, he changed tactics and sought sympathy from the McGlincy clan. One evening a few months before the murders, Dunham returned to the ranch from San Jose with a curious story. He told the colonel and his brother-in-law, Jimmy Wells, that he had been stopped on the road by two men, robbed of $1,000 and then set free by a tramp who happened along the road after the robbers were gone. The colonel and Wells both expressed their view that James had concocted "a fish story." The ranch hands were said to have "guyed" him over the story as well.

Perhaps in an effort to gain more respect from Hattie and other members of the McGlincy clan, Dunham enrolled in Santa Clara College as a pre-law student. The decision to pursue a lucrative profession may also have been motivated by news that the couple had a baby on the way. On May 4, 1896, just three weeks before the killings, Hattie gave birth to a son, Percy Osborn Dunham.

As he was thirty years old and married when he entered Santa Clara College, Dunham had little in common with his much younger fellow students. The *San Jose Mercury* quoted one student who said that Dunham had "a cheery way of greeting people, but there was something about him that prevented many from cultivating an acquaintance." He was known as a diligent student who generally kept to himself. In fact, in the wake of the murders, the vice-president of Santa Clara College, Reverend Robert E. Kenna, expressed surprise that a loner such as James Dunham was even married: "He was in a degree inapproachable. He was always very polite and would bow to those with whom he was acquainted, but he very seldom showed a disposition to talk to anyone, and he seemed to be a very hard person to become very well acquainted with. He was, I might say, a silent man. He rarely if ever smiled, and had what might be called a far-away expression."

He made few acquaintances at the college and was consumed with an extraordinary academic load that entailed completing a four-year degree within two years while also making up extensive coursework in Greek and Latin that would be required to enter law school. Although some of his classmates described Dunham to reporters as "extremely dull mentally," Reverend Kenna told the *Mercury* he was performing relatively well in his

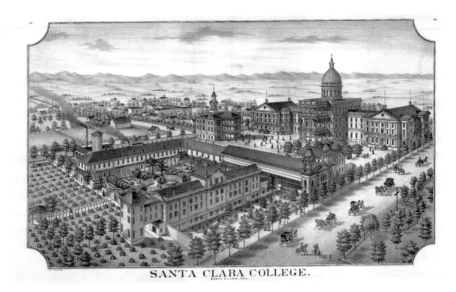

SANTA CLARA COLLEGE.

Dunham was a student at Santa Clara College (now Santa Clara University). Founded in 1851, the campus surrounds historic Mission Santa Clara de Asis. Illustration circa 1876. *Courtesy History San Jose.*

academic studies. "His standing in Latin and Greek thus far is 84 and 88, which is very good. In deportment he stood 100. Of course in his other studies—that he did not have to make up so much in—he was also pushing right ahead."

By May 1896, Dunham's relationship with the McGlincy family had become severely strained. According to George Schaeble's testimony during the coroner's inquest the morning after the crime, the nightly card games Dunham and the colonel played together abruptly stopped about six weeks before the murders, and the two men ceased speaking to each other.

Hattie's mother, Ada, was not enthralled with her son-in-law either. Over an extended period of months leading up to the murders, she maintained a journal containing seven pages of incidents describing James's numerous inadequacies as a husband. She most likely was compiling documentation in preparation for divorce proceedings.

The possibility of a divorce was corroborated by the grief-stricken parents of Minnie Shesler, the domestic helper. Contacted at their home on Delmas Avenue in San Jose the day after the murders, the couple recalled their daughter telling them that Mr. and Mrs. Dunham were not happy and that a divorce suit might be expected. The surviving ranch hand, George Schaeble,

and other acquaintances shared similar reports of the couple's quarrels. Some even said that James threatened to kill Hattie.

Mrs. H.M. Parker, a nurse who attended to Hattie for a period of thirteen days before, during and after the birth of the Dunham child, told reporters that Dunham showed his wife "no more respect than if she had been a beast." Mrs. Parker said that one day, Hattie said to her "what kind of man do you think I have for a husband, when he tells me he will take my baby to Mexico, start a gambling house and saloon there, and bring up my child a Catholic?" (Although Dunham attended a Catholic college, both he and his wife were Protestants.) While Dunham neglected his wife, refusing simple requests for things such as a glass of water or mosquito netting, Mrs. Parker noted that he showed great affection for the baby. "He held it in his hands a great deal and used to lie on the bed with it, proud of it."

Evidence of the strained marriage provided perplexing context to a note crime scene investigators found on Hattie's bureau that closely matched her handwriting: "Please say goodbye for me to my dear mother, brother and stepfather. Hattie."

The note was deemed a forgery by numerous authorities who analyzed it. Comparing it to handwriting samples of both Hattie and James, resemblances to Dunham's chirography were spotted. To this day, however, mystery enshrouds the scrap of paper. If James forged the message, was it to create an illusion of suicide? Or did he intend to hide her body, leaving the impression she had run off?

If the handwriting analysis was wrong and Hattie indeed wrote the note, did she write it on the night of the murder, in fear for her life and in anticipation of her inevitable death?

The *San Francisco Call* published this note that was found on Hattie's bureau. Experts concluded that it was forged by Dunham.

Did James grant her a moment to record her final goodbyes? A less plausible theory holds that James seduced Hattie with a romantic plan to flee the ranch and start a new life together in a distant location. Oblivious to her husband's evil intentions, she wrote the note prior to departure.

Police interviews with people who knew Dunham revealed several anecdotal pieces of evidence that

strongly indicate that the mass murder was not an impulsive act of rage but rather premeditated and carefully planned by a devious, coldblooded psychopath at least several weeks in advance.

A young man named W.H. Johnson shared a chilling story with reporters. Mr. Johnson was a student of a respected attorney named John Goss. According to Johnson, Dunham had recently retained the legal services of Mr. Goss regarding the foreclosure of his mortgage on a property of A.C. Penniman. A few weeks before the killings, Dunham and Johnson happened to both be at Mr. Goss's office and became engaged in a friendly conversation:

> *In that conversation, he asked me this question. "Providing a man marries into a wealthy family and has issue and afterward the entire family should die, would that child inherit the entire estate?" I promptly replied, for I had given this subject considerable study, "it would."*
>
> *He then said: "Are you sure?" and I remember now that he accented the word "sure" and looked me straight in the eyes.*
>
> *I told him that that was the rule of consanguinity.*
>
> *He then said: "I'm glad of that" and then covered what he said by the further remark; "I'm glad of that, as I intend to study law myself and am anxious to learn legal points."*
>
> *In talking to me he seemed to speak very rationally, and his actions would indicate that he was a very deliberate man. I knew he intended to study law, and I was not in the least surprised that he asked this question, but little did I think that I was furnishing information upon which Dunham was founding his plot to strike down a whole family.*

Mrs. McGlincy's brother-in-law, George Brewer, had no doubts about Dunham's state of mind:

> *There is no question in my mind that he murdered Colonel McGlincy and his whole family because he knew that the valuable estate would revert to him through his son, and he betook pleasure in his bloody work because he had a personal spite to revenge.*
>
> *My theory is that he never intended to murder the hired men—only the people in the house. And he intended to do it all with the keen-bladed ax with which he murdered Mrs. McGlincy and leave no clue, but his plans miscarried. He knew the habits of everyone in the household and knew that McGlincy and Wells had gone to San Jose and knew when they would return. He knew, too, that it was customary for young Wells to assist in*

putting up the horse, and that the old man would most likely enter the house first. No doubt he counted upon the fact that Wells had not yet recovered from a bicycle accident which came near ending his life. He would be too weak to offer much resistance.

Dunham spent the night previous to the murders in San Jose. He did not ride out to the McGlincy house until 9:30 at night. It was his intention to murder all the women noiselessly, and he did it. Mrs. McGlincy made an awful struggle for life, but had not had the strength to cry out.

Then the murderer sat down, almost in the blood of his victims, to await the homecoming of the men. He probably intended to fell the old man as he entered the door with the ax. Wells was to have met the same fate. Then the fiend would have ridden swiftly and silently back to town on his wheel, ready to prove an alibi in case suspicion should fall upon him and be ready to dissemble over the lifeless body of his wife.

But his plan his plan had not counted upon the strength and vitality of McGlincy. The old man was undoubtedly struck down at the door but revived while the murderer was engaged with Wells, and escaped through the window to the shanty. Dunham was compelled to use his pistol to save his own miserable life, and it was through its use that his villainy was discovered.

Don't talk to me about insanity. He was as sane as you or I, but a natural-born villain and murderer. He did not act like an insane man. There was a method in his madness from start to finish. He wanted the property. By killing off the whole family he could secure it. He planned cleverly and executed well up to a certain point, when the merest chance, you might say, undid him. He cared not a snap of your fingers of human life. Affection for wife or babe was to him a thing unknown. He has gained the property, but will forfeit his life for it if justice is meted out to him.

The night before the murders, Monday, James did not return home after school. His whereabouts are unknown, but it was not unusual for him to occasionally stay elsewhere overnight, especially given the tension at the ranch.

The *San Francisco Call* reported that at 7:00 a.m. Tuesday morning, Dunham was seen at the saloon of J.A. Belloli at the corner of South Third and San Fernando Streets. He was slumped in a corner of the saloon, appearing tired, with his head buried in his hands. According to the barkeeper, he wasn't drinking and ate a hearty breakfast. Shortly before 10:00 a.m., Roy Guilkey, an employee of the Osgood & Smith Cyclery on South First Street,

Artist's rendering of Roy Guilkey, the young bicyclist who saw Dunham at a San Jose saloon on Tuesday morning. Published in the *San Francisco Call*, June 4, 1896.

entered the saloon and recognized Dunham, a customer of the shop and avid cyclist. He was surprised to see him there because Dunham was not known to be a drinker. Observing his drowsy appearance, Guilkey chose not to engage Dunham in conversation.

According to the *Call*, after leaving the bar, Dunham went to the bank, withdrew his entire balance of more than $1,000 and then went to the college. Dunham was known to take his books home from school each day, but on the day of the crime, he left them at school. It seems he knew he would no longer be needing them.

J. Kirkpatrick, another employee at the Osgood & Smith bicycle shop, told authorities that he saw Dunham in the shop on Tuesday afternoon, working on a bicycle with James Wells just hours before the killing rampage. Dunham had ordered a bicycle tire from an establishment back east that was to be delivered to the shop on that day. He showed up at the store around noon. The tire had not arrived, so he left the store and returned at 4:00 p.m. The tire had still not arrived, so he left at around 4:15 p.m.

During that brief stop, he visited with Kirkpatrick, who recounted that Dunham appeared "no more insane than you are." Kirkpatrick said Dunham was "full of bicycle talk," and he detected no indication that Dunham would be committing the awful crime that happened later that night. That night, the methodical execution of Dunham's plot was not derailed or significantly impeded by the messy bloodshed necessitated by the resistance of his victims.

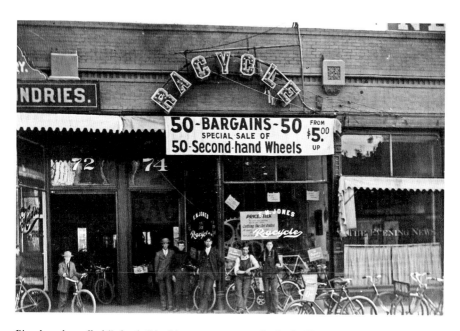

Bicycles, also called "wheels," had become very popular in California by the turn of the century. Shops such as Osgood & Smith, where Dunham was seen the day of the murder, and Racycle (seen here), were common in Santa Clara County. *Courtesy History San Jose.*

In the dark hours between the murders of Hattie, Minnie and Ada and subsequent murders of Colonel McGlincy, Jimmy Wells and Robert Brisco, amid the butchered corpses of his wife, mother-in-law and nanny to his son, Dunham, alone in a house drenched in blood, showed no signs of remorse, panic or fear. To the contrary, he was emotionally detached and cool enough to prepare for the next phase of his diabolical plan.

Those preparations included gathering a .38-caliber revolver, a .45 and every cartridge in the house. Both guns were subsequently put to use, although perhaps not in accordance with the killer's plan. According to the *Mercury*, Jimmy Wells took three .38- and two .45-caliber bullets, with rounds entering his chest, back, shoulder, thumb and jaw. The latter "passed out of the cavity of the skull just back of the right ear, then followed the line of the scalp to the center of the head." Five more bullets hit the colonel, leaving wounds in the right arm, right shoulder, right lung and the fatal shot through the heart. Only two bullets were needed for Brisco—one through the heart and one through the right lung.

Deputy Sheriff Black told reporters of something else Dunham did during the intermission: "He had sense enough to take all the pictures of himself out of the house before he left, including a large portrait of himself hanging in the parlor. Dunham has evidently escaped to the mountains. There is no question he will be caught."

Indeed, the only picture of Dunham that law enforcement had to work with was a small tintype of him and his wife taken at Ocean Beach in San Francisco that he apparently had overlooked.

Family Influence?

Today, it is widely believed that the symptoms manifested by psychopathic killers are correlated with brain abnormalities. Using medical imaging techniques, neuroscientists have discovered that the brains of psychopaths have noticeably thinner tissue in key subcortical areas.

These regions span the limbic system and other structures, such as the orbitofrontal cortex and the temporal pole, that are adjacent to the limbic system. They are collectively known as the paralimbic system, which experts believe may hold the key to understanding psychopaths. This is because the paralimbic system controls basic emotions such as fear, pleasure and anger and handles decision-making, reasoning and impulse

control. If this tissue is damaged or underdeveloped, then that person may have a decreased ability to register feelings or assign emotional value to experiences. It explains a great deal about the behavior of psychopaths, who have difficulty feeling emotions.

Is it possible that James inherited a genetic trait that contributed to an underdeveloped paralimbic system? In his eulogy for Dunham's victims, Reverend Haskell noted "the causes that led to this crime lay in the murderer's ancestry." Although the reverend was presumably speaking in a biblical context, an examination of Dunham's family history suggests that ancestry indeed may have been a factor in the crime.

James was born in 1865 to Isaac and Kate Dunham in Dulzera, California, about ten miles north of the Mexican border. Isaac was a rancher of considerable means. Kate, a native of Ireland, was known among acquaintances in San Jose as "Kate the Terror," a moniker owed to her legendary violent temperament. Santa Clara County assessor Spitzer, who came to know her well before her death three years prior to the murders, said she had the most violent temper of any human being he ever knew.

If James's vicious maiming of his mother's chickens a decade earlier was triggered by a hereditary trait passed down by his mother, it was not an isolated incident. In the spring of 1893, Dunham had been employed as a laborer on a ranch in Chico owned by a sixty-three-year-old man named Fred Ackerman. A few months after Dunham arrived, friction developed between the two men. The deteriorating relationship came to a head one afternoon while Ackerman was in the barn saddling his horse. Without warning, Dunham attacked the older man from behind, pinned him to the ground, grasped him by the throat with one hand and held the other hand over his mouth to prevent him from shouting for help. Dunham then attempted to break Ackerman's neck by twisting his head. Another ranch hand heard the commotion and arrived at the barn just in time to rescue the old man from Dunham's clutches. Dunham's employment was terminated, but before leaving, he made sure to tell some of the men that he wished he'd killed Ackerman. He explained that it would have been easy to claim that Ackerman broke his neck and died by falling from the hay loft.

District Attorney Bert Herrington's perspective on Dunham's demeanor was based on years of neighborly proximity to the killer. "He was always a determined, desperate fellow—a man of violent and ungovernable temper. He used to live near me at Santa Clara, and I know he was a fellow who was up to all kinds of devilment. As a boy, he would never stand the blame, but

would always put it off on somebody else. There was a rumor years ago that he chased his sister and mother through the yard with a hatchet."

Herrington's recollection was echoed by others. George Schaeble told authorities, "Dunham was always having trouble with the family. He had a row with the servant girl [Minnie] on Monday morning over his breakfast." As Minnie would tragically discover in her final moments of life, the swinging of hatchets and the twisting of necks came easily to James Dunham.

James's siblings, while lacking their brother's temper and indifference to all living things, were not entirely well-adjusted, mentally stable members of society either. Addie, the youngest, was emotionally frail and insecure, heavily dependent on her mother for encouragement and financial support even as she approached adulthood. Charles, the middle child, was at the very least an odd individual prone to quirky behavior.

A story that ran in the papers in 1892 involving Charles sheds light on the younger brother's personality. In early March, two days before Charles Dunham and Mattie Gardener, the nineteen-year-old daughter of a wealthy Saratoga fruit grower, were to be wed, the couple suddenly and mysteriously disappeared. Mattie's parents were alarmed and bewildered, as elaborate arrangements had been made for the ceremony to be held at their residence.

The media was notified, casting the couple in the public eye and prompting incongruous speculation from acquaintances and relatives regarding possible motives and whereabouts. A Second Street stationer named Henry Miller, with whom Charles had been recently employed, told a reporter that he had known of his employee's planned departure for several weeks. Miller said that Dunham had intimated to him that his entangling relationship with a young lady was worrying him, in part because he had eyes for another woman.

Charles's mother, Kate, also spoke to the press, expressing her belief that Charles was in Fresno. No explanation was offered as to why he was there, or even if Mattie was with him.

Days later, the couple resurfaced in Fresno with news that they were married, leaving family, friends and an interested public at a loss to why they had eloped. The intrigue grew when Mattie's brother provided a baffling explanation to a local reporter. He alleged that someone who did not want the marriage to occur offered Charles money to disappear; instead, Charles ran off and married the girl he loved. Charles denied his brother-in-law's account, stating, "I did not accept any money. No money was offered to me and no one ever tried to get me not to enter into the marriage or ever offered me any inducements at all not to enter into the marriage. When Gardner

made that statement about the money, he knew it was not true and he knew the facts of the case." The only explanation Charles offered for the bizarre behavior was the couple's desire to do something romantic.

Shortly after the marriage, Mattie filed for divorce on grounds of desertion. In December 1892, the *San Jose Evening News* reported that Charles would be tried before Justice King on a charge of neglecting to provide for his three-year-old son. According to the report, Dunham had run away with, and married, Miss Gardner of Saratoga and then deserted her. It is unclear from newspaper accounts if Charles was the biological father of the child or if another man fathered the child before Mattie and Charles became a couple.

Mattie also filed a suit against Charles in October 1893, before the divorce case was even settled, asking for back alimony of $1,000. It was requested the amount be declared a lien against real estate that had been left to Charles by his late mother, Kate. In January 1894, Charles filed a formal response with the court. In answering her charges, he alleged that on March 27, 1892, he and his wife entered into a verbal agreement not to live together and that since that time, she had been living with her parents in Saratoga and has made no effort to return to their home.

Another illustration of James's and Charles's oddities occurred when their father, Isaac, passed away in October 1894. Isaac's neighbors had buried him on the Dulzera property in accordance with his wishes. Within days, however, the brothers visited the ranch, reportedly intent on exhuming their father's body and having it sent to San Jose for burial. By the end of their first day, the brothers determined that the body was impossible to remove from its freshly dug grave and abandoned their effort. As implausible as that claim seems, the old man's death wish was preserved, and the brothers turned their attention to what was likely a much higher priority.

Isaac's neighbors had given the sons some papers relating to the estate, along with $595 in cash, which had been dug up from four different places on the ranch. It was thought that Isaac had buried several thousand dollars in that manner. The brothers deposited the cash in a safe in the city, telegraphed their sister, Addie, in San Jose regarding their father's remains and returned to the ranch the following day to resume the search for the family fortune. When interviewed by local reporters, Charles was reticent to disclose the amount of cash buried on the ranch but intimated that papers existed showing where the money could be found.

Now, with his brother center stage in lurid headlines regarding the most horrific crime anyone could remember, Charles seemed eager to take the spotlight. He was among the curiosity seekers who showed up at the crime

Dunham's younger siblings, Charles and Addie, both attended San Jose Normal School, which today is San Jose State University, photo circa 1895. *Courtesy History San Jose.*

scene the next morning. After being denied an utterly bizarre request to see Hattie's body, he volunteered his assistance in the capture of James. He furnished the officers with an accurate description of his brother and even described his clothes. Speaking to a *San Jose News* reporter, Charles attributed his brother's evil act to insanity brought about by the stress and exhaustion of his academic workload:

> *There is no doubt but that my brother was insane. He was a hard and assiduous worker all his life. He was a graduate of the San Jose High School and recently had been taking a course of Latin and Greek at the Santa Clara College and he had taxed his brain severely in the effort to accomplish in six weeks what the course prescribed requires six months of study.*
>
> *There is not the slightest truth in any report that there was trouble in the family. My brother and his wife were married a little over a year ago. He loved his wife dearly and she reciprocated his love deeply. The whole family loved him and even idolized him, and when I was out to the house a week ago to visit them I found them enjoying perfect happiness. James' wife then told me that they were all so happy and that James adored the little one just born to them on the 4th of May. At morning and night, she said that James played with the child as if his entire life was wrapped up in it.*

45

Yes, I want to see that James is incarcerated as soon as possible and I want to give the officers as much assistance as is in my power to locate him. I have no idea where he might have gone, for I know of no place where he could secure protection and shelter, or where he might apply for assistance. He is thirty-one years old and I am twenty-five. My sister, who attends the Normal School, is about twenty-two years of age. This will surely kill her, or it will be a severe blow to her at least, for she is not strong and since the death of our mother, three years ago, she has been almost broken-hearted, for they loved each other so dearly.

MANHUNT

A s the sun came up on Wednesday morning, a massive manhunt was beginning to take shape. It was Lyndon's opinion that Dunham was headed south and would likely travel at night by the light of the moon and sleep in hiding during the day. In Sacramento, California governor James Budd wasted no time to approving a bounty of $1,000 within a day of the murders. So inspired, citizens began independent searches up and down the state, augmenting the work of law enforcement officers.

San Luis Obispo County sheriff Stephen Ballou responded to Sheriff Lyndon's request for help with a telegram promising to be on the scene that evening with his pair of renowned bloodhounds to pick up the trail. With his dogs, extensive familiarity with the terrain of central California and vast network of friends in law enforcement and government, Ballou would be a valuable addition to the search team.

Such direct action was characteristic of Stephen Ballou. Volunteering at the tender age of sixteen to join the Union army in the Civil War, the native of New York suffered wounds from which he never fully recovered. Discharged honorably in 1865 at age twenty, he ventured west via the Isthmus of Panama. For the next eleven years, he engaged in a number of enterprises. He worked in a mining operation in Nevada, farmed in Monterey County, opened a store in Lompoc, was a merchandiser in Arizona and ran an extensive farming operation in Fresno before becoming a permanent resident of San Luis Obispo County in 1876. A staunch Republican, Ballou operated the lighthouse at Port Hartford (later known as Port San Luis) and

PLEASE POST THIS IN A CONSPICUOUS PLACE.

ARREST FOR MURDER!

$1000 REWARD.

Will be paid by the Governor of the State of California for the arrest and conviction, and the citizens of Santa Clara County are now soliciting subscriptions for an Additional

REWARD OF $10,000

a considerable portion of which is already subscribed, for the capture DEAD OR ALIVE) of

JAMES C. DUNHAM

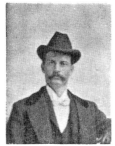
TAKEN IN 1895.

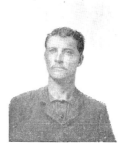
TAKEN IN 1889.

On the night of May 26, 1896, near Campbell, Santa Clara County, California, James C. Dunham brutally murdered Mrs. R. P. McGlincy, Mrs. Hattie B. Dunham, Miss Minnie Schessler, Col. R. P. McGlincy, James K. Wells, and Rober A. Brisco.

He is a bicyclist and may be on a wheel. About 32 years of age, 5 feet 11 inches high, weight 165 or 170 pounds, has sharp features, dark hair and mustache, blue eyes, medium complexion; when last seen he wore black suit, cutaway coat, black soft hat, number 9 shoes, sharp pointed toes. Walks very erect, chin recedes when he laughs. May have shaved and changed clothing and shoes. One eyelid droops slightly, parts hair on right side.

The undersigned will assist any person knowing the whereabout of said James C. Dunham, in taking him into custody, and will waive all right to claim the rewards offered for said arrest to and in favor of the person giving to me the information which will lead to the capture of the said James C. Dunham.

Wire all information to me at my expense.

J. H. LYNDON, Sheriff.

San Jose, Santa Clara Co., California.

The State of California offered a $1,000 reward, supplemented by $10,000 from private sources. *Courtesy Campbell Historical Museum.*

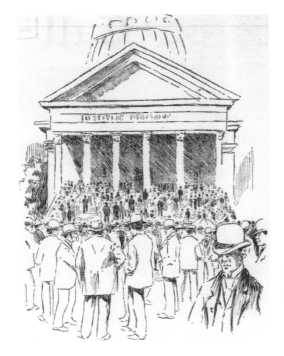

Artist's rendering of excited crowds in front of the courthouse in San Jose, eagerly awaiting news of Dunham's whereabouts. Published in the *San Francisco Call*, May 30, 1896.

was also engaged in the tea and coffee business. His public service included terms as sheriff and later postmaster of San Luis Obispo County.

In Justice Glass's downtown San Jose courtroom, under the direction of the District Attorney's Office, Constable Haley swore to a complaint charging James Dunham with murder, and an arrest warrant was issued. In the eyes of the law, Dunham was now officially a wanted man. As word of the crime spread, rumors began circulating of citizens' plans to bypass the formalities of due process and administer justice by lynching Dunham.

By late Wednesday morning, officers found Dunham's bicycle hidden in some brush along Dry Creek, which ran near the McGlincy ranch. The previous evening, at around 9:00 p.m., before the killing spree began, a witness saw two bicyclists riding down the road toward the McGlincy's. The witness was unable to visually identify the wheelmen (as bicyclists were called then) but overheard them talking. He believed one of the voices was that of James Dunham. Authorities suspected that Dunham may have concealed the wheel before the murders with plans to recover it as a getaway vehicle if he had been unable to secure a horse. Dunham was an expert wheelman who was used to riding long distances.

Authorities speculated that had Dunham used the wheel, he would have taken valley roads to escape. The fact that he used a horse led them to believe

that he had headed for the mountains. Some officers believed that he might have prepared a secret hiding place in the hills, stocked with a supply of provisions that could last for weeks.

According to that theory, once the search was concluded, Dunham would slip out of the county. There were differing opinions about how much cash James may have had at his disposal. Henry Miller, the paper dealer who employed James's brother, Charles, said the fugitive may have as much as $20,000. Others who knew Dunham thought that figure was on the high side but conceded that he might have had between $15,000 and $20,000.

HOUNDS IN THE HILLS

At 5:00 p.m. on Wednesday evening, Sheriff Ballou arrived at the train depot from San Luis Obispo. A huge crowd was on hand at the train station, eager to see the famous bloodhounds, Trim and Flora, that had been brought up for the search. A newspaper account of the scene suggests that the crowd may have been somewhat disappointed with what they saw: "The dogs were not as ferocious-looking as had been expected. They were not of the 'Uncle Tom's Cabin' spectacular kind, but rather small, nervous acting animals, who tugged at their chains constantly."

The dogs were taken directly to the McGlincy ranch, where they were expected to pick up the trail of Dunham. The hounds' efforts, however, were impeded by hundreds of new footprints laid down on the property by law enforcement officers, neighbors, reporters and curiosity seekers in the hours preceding Ballou's arrival. Although Ballou anticipated that it would be difficult for the dogs, he explained that if they could pick up Dunham's scent, they would be able to follow it even if the killer remained on horseback.

Just as the party was preparing to depart the McGlincy property, a telephone message was received stating that a man who matched the description of Dunham had been seen at approximately 6:30 p.m. at the Smith's Creek Hotel. Situated as it was in the foothills below Mount Hamilton, the highest peak in the Diablo Range bordering the east side of the Santa Clara Valley, the hotel was a gateway to hundreds of square miles of sparsely populated wildlands. Furthermore, atop Mount Hamilton was the first permanently occupied mountaintop observatory, built between 1876 and 1887 from a

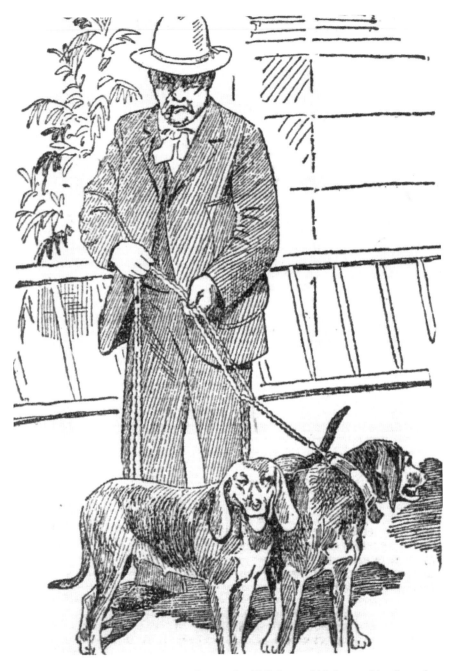

Artist's rendering of San Luis Obispo County sheriff Ballou and his famous bloodhounds. Published in the *San Francisco Call*, May 30, 1896.

Abvoe: Lick Observatory at the summit of Mount Hamilton, 1885. *Courtesy History San Jose.*

Opposite, top: The rugged terrain of Mount Hamilton is part of the Diablo range, which extends from the eastern San Francisco Bay area south to the Salinas Valley. *Courtesy History San Jose.*

Opposite, bottom: Chinese camp during the construction of Mount Hamilton Road, circa 1876–86. *Courtesy History San Jose.*

bequest by James Lick—and the "first-class road" to the summit offered any fugitive a rapid escape into these open spaces. Now that road doubtless called to a savage murderer on the run.

Encounter at Smith's Creek

Everett Snell, the son of San Jose pioneer settler Thomas Snell, lived at the Snell ranch, on which the Smith's Creek Hotel was located. He and his friend Oscar S. Parker, an employee of the nearby Morrow ranch, had been on their way to Parker's cabin, located about a mile from the hotel.

It was dusk when they reached Parker's abode. A man exited the cabin and approached them. He was leading a horse that looked like the one

taken from McGlincy's stable, and the horse had no saddle. The man was wearing gunnysacks over his feet and possibly was not wearing shoes underneath them. He was carrying a sack on his shoulder, and his face was badly scratched.

Although Snell had known Dunham in the past and immediately recognized him, he acted coy, drifting down the trail toward the hotel, pretending not to recall the stranger's identity. Parker, noting his appearance and the unbridled, saddleless horse, quickly came to the realization he was none other than James Dunham. Masking his awareness of Dunham's identity, Parker approached him. "Hello, where did you come from? The San Joaquin?"

"Yes," the stranger lied. "I've been up to the cabin there and broke in. I haven't had anything to eat in two days and had to get something so I got in and took some bacon and prunes." Parker invited the stranger to stay the night. After giving the offer some consideration, Dunham declined. He then pointed to Snell, who was still sauntering to the hotel. "Who is that?" he asked.

"Him? That's my friend Everett Snell."

Upon learning this information, Dunham suddenly became anxious to move on. "Say, is there a trail that will get me into the San Joaquin Valley?"

Smith Creek Hotel, circa 1890s. *Courtesy History San Jose.*

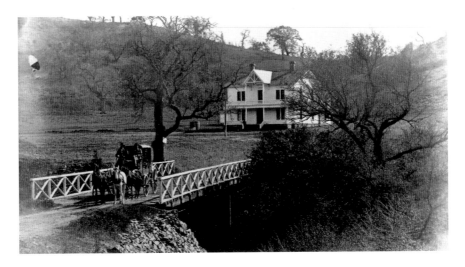

On the road to the Lick Observatory near San Jose and the Smith Creek Valley, hotel and bridge. *Courtesy History San Jose.*

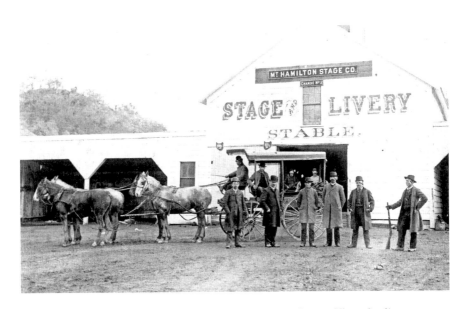

Smith Creek Livery and the road to the hotel, circa 1890s. *Courtesy History San Jose.*

Parker advised him to take the trail to Mount Hamilton Road. He wanted to keep the man on the main road so that he could be more easily found.

Dunham chose to not heed Parker's advice. "I guess I'll go up Smith's Creek and over the mountains," he said.

Parker, determined to keep the man on the main road, crafted a clever lie. "You had better not go that way, as there are officers over there looking for cattle thieves and they might run on to you."

"Well, I don't want any of that."

"Yes. They might catch you and hold you for a cattle thief." With that, Dunham led his horse toward the road and disappeared behind a knoll. Parker then ran and caught up with Snell, and upon reaching the hotel, they immediately notified the Sheriff's Office.

In short order, the sheriff's posse and the dogs were on the road to Mount Hamilton. The posse included Sheriff Ballou; Sheriff Lyndon; Deputies Kennedy, Headen and Reynolds; Constables Coschina and Haley; and Al Hanks, Charley Simmons and J.W. Reed. They were accompanied by about twenty bounty hunters who were motivated by the reward money and the thrill of the hunt.

The posse had assembled at the Smith's Creek Hotel by about 10:00 p.m., as the moon was rising. Winchester rifles occupied every corner, pistol handles bulged from pockets and tobacco smoke hung in the room as the hotel's manager, Everett Snell, served meals.

Several circumstances conspired to handicap the search effort. The darkness prevented Ballou from dispatching his dogs to track the scent, so they stayed behind. In their haste to reach the scene, the posse had only been able to find five saddle horses. And by 1:00 a.m., a dense fog had rolled in over the mountain, forcing the searchers to return to the hotel.

Around 3:00 a.m., the fog began to clear, and once again, the officers took up the search under the bright moonlight. Sheriff Lyndon opined that the fugitive was tired and had likely found a secluded place to rest.

By this time, the search team had gotten larger, and an established methodology was in place. Sheriff Lyndon's deputies would depart at daybreak from the Smith's Creek Hotel, and groups of two or three men were stationed to guard passageways overnight. The latter were required to report at dusk. The sheriff maintained a territory map so that he would know where each of his men were at all times in case he needed to summon them. If any man failed to return to base at dusk, others could be sent after him.

Everyone was under strict orders not to shoot the fugitive unless it was absolutely necessary. The sheriff wanted Dunham captured alive. It was

Everett Snell and Oscar Parker encountered Dunham near the Smith's Creek Hotel. This photo of Snell was taken on Mount Hamilton in 1910. Snell Road in San Jose is named after Everett's father, Thomas, a county pioneer. *Courtesy History San Jose.*

Left: Horse-drawn carriages on Mount Hamilton Road, circa 1880s and 1890s. *Courtesy History San Jose.*

Below: Artist's rendering of the sheriff's posse at Smith's Creek. Published in the *San Francisco Call*, June 2, 1896.

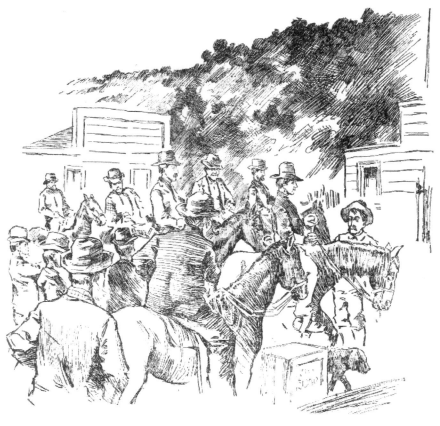

expected that, if encountered, he would put up a fight. For that reason, officers were instructed to fire two shots in rapid succession, followed by pause, then two more shots as a signal to rally sufficient forces to overwhelm Dunham and stifle any resistance he may put up. In the stillness of the mountains, shots could easily be heard from at least five or six miles away.

Legendary lawman Juan Edson and former Santa Clara County sheriff George Bollinger teamed up to lend their support to the cause of tracking the killer down.

JUAN EDSON

Juan Edson was a colorful lawman and attorney in San Jose for several decades. The only boy in a family of five children, Edson began his career as a deputy constable for the township of San Jose on September 12, 1877. First appointed by then sheriff Hugh A. DeLacy, Edson engaged in the pursuit of some of California's most famous criminals, including the legendary bandit Tiburcio Vasquez. A central figure in the hunt for James Dunham for many years, Edson's interesting life merits elaboration.

Among his early acts of heroism was the recapture of Dick Fellows (aka Dick Little), one of the most notorious stage robbers of the American West. Fellows first arrived in California in 1849 at the age of fifteen. For several years, he served as a messenger for Joaquin Murietta's band of outlaws before going out on his own, robbing stagecoaches carrying gold mined in the placer mining country at the height of its prosperity. His range expanded to include the Sierras and the Coast Range from Oregon to Mexico, with his depredations mainly consisting of taking the strongboxes of the stagecoaches of express companies. Fellows's portfolio of victims included the Wells Fargo Express Company, which placed fabulous prices on the bandit's head.

In 1881, Fellows escaped custody after a massive manhunt led to his capture near Mayfield (now Palo Alto). Cornellus Van Buren, who at the time was a Mayfield deputy sheriff and later became a revered justice of the peace, outdrew Fellows and forced his surrender. Van Buren turned the outlaw over to Constable Burke, who was tasked with transporting the prisoner to San Jose. During the journey, the famous robber bonded with the constable by regaling him with tales of treasure he'd stolen and hidden in different places. Upon arriving in San Jose, the constable decided to stop at a saloon in town for a few drinks before depositing Fellows at the jail. As they

stepped out of the saloon, the handcuffed Fellows pushed Burke face-first to the ground and escaped in the night.

Law enforcement officers throughout the state were chagrined at the news of the inexcusable escape, and for eight days and nights, men scoured the county, finding no trace of Fellows. Finally, acting on a tip that Little had taken refuge in the hills around the world-famous mercury mines of New Almaden, Edson and San Jose police chief Dan Haskell tracked him down in an isolated mountain cabin near Guadalupe. They surprised the fugitive as he was cooking supper, restrained him and, in short order, had him locked up in San Jose. Sometime later, he was sent to Santa Barbara, where he was tried, convicted and sentenced to life in prison at Folsom. The day he was to be transported from San Jose, the slippery convict escaped custody once again; however, he was captured the same day and sentenced to spend the rest of his life behind bars.

Despite the bandit's notoriety—he was ultimately a three-time California state penitentiary inmate—Fellows had never killed a man, only shot in self-defense and never robbed an individual. This, combined with an engaging personality, resulted in him receiving three different pardons. For reasons unknown, he refused one of the pardons from a certain California governor, instead serving an extra thirty years in Folsom Prison. When he was eventually released, he went on to pursue a career that included serving as an interpreter in the office of the general counsel of Guatemala and performing a sharpshooting act at fairs and expositions across the country.

In March 1915, Fellows paid a visit to San Jose while on his way to San Francisco, where he was to perform a reenactment of his remarkable exploits recalled from his early days at the "Forty-nine Camp." His visit was deemed worthy of coverage by the *San Jose Mercury News*, which described the former bandit as "still hale and light-hearted at 80, keen of eye and still possessing the ability to draw and shoot more quickly than the majority of the nation's crack shooters."

Another of Edson's famous adversaries was Ramon Luis, a renowned bronco rider, gunslinger and stagecoach robber who was born in 1839. Lawmen of Calaveras, San Joaquin, Santa Clara, Stanislaus and Merced Counties all agreed that one of the most dangerous combinations they had to contend with consisted of Luis, a good mustang and a pair of six-shooters. Luis served time in San Quentin Prison for stagecoach robbery, working in gangs and as a lone highwayman who, like Dick Fellows, counted the Wells Fargo Company among his favorite targets.

Luis was a popular outlaw known for spending his ill-gotten gains lavishly and generously on those who harbored him or showed him kindness. He was also known as a man who never forgot a friend or forgave an enemy. After living a fast-paced life and laughing at bullets, he surprised all those who knew him by dying unceremoniously in a Calaveras County jail cell. He caught a cold while selling tamales on the street at night, developed consumption (tuberculosis) and died quietly within thirty days.

In the spring of 1884, Edson was instrumental in assisting then sheriff Ben Branham in the capture of John Waseliege, an ex-con who had once served two years and nine months in San Quentin for grand larceny. At the time of Edson and Branham's pursuit, Waseliege was a fugitive, wanted for the brutal murder of his ex-wife two years earlier in Los Gatos. Waseliege had stabbed her thirteen times. As the woman lay dying in a pool of blood, she uttered the identity of her assailant to a first responder at the scene. It was her ex-husband, who by then had fled the area. Edson had taken a profound interest in the case and assisted Sheriff Branham in his pursuit.

Edson tracked the killer from California to the Sandwich Islands and from there to Silver City, New Mexico, where Waseliege had been arrested and sentenced to a year in jail for stealing a mule. While in jail, he complained about "rheumatic affection" and was granted certain liberties in the infirmary that enabled him to scale the walls and escape. He was later apprehended in El Paso and released to the custody of Edson and Branham. The two lawmen found time for recreation during their trip from San Jose to El Paso, slipping across the border into Mexico to take in a cockfight.

Edson later sought reimbursement for the considerable amount of money expended in his relentless three-year pursuit of Waseliege, but in February 1885, Santa Clara County Superior Court judge Belden ruled that Edson, who had been elected by the San Jose City Council as a "police officer, to serve without compensation from the city," had no valid claim against the county for fees in services for state cases. Edson persisted and ultimately received partial reimbursement sixteen years later. In March 1901, an act of the California state legislature awarded him $1,500. Although his actual expenses were double that sum, Governor Henry Gage had indicated that he would veto any appropriation to Edson exceeding $1,500.

Although acclaimed for his exploits in enforcing the law, Edson himself was convicted of felony bribery under questionable circumstances in 1885 while acting as an officer. In response to a complaint filed by a local citizen, Edson and a fellow officer had arrested a man named Scossa, along with another man and a woman named Chona Felis on charges of vagrancy for

residing at a house of prostitution. Scossa was subsequently set free after Edson was paid twenty-five dollars. It was alleged that Edson accepted the money as a bribe. Edson argued that the payment was made by Scossa's accomplice, Chona Felis, for legal services he had performed for her prior to and completely unrelated to the arrest. Edson maintained that acting as Felis's lawyer, he had represented her in the settlement of an estate in Napa that was owned by her sister. He insisted that that the money received from Felis had no connection with Scossa's arrest and that the bribery charges were motivated by spite.

Edson's defense failed, and in October 1885, he was convicted and sentenced to two years in the state prison. In February 1886, the California State Supreme Court reversed the ruling and ordered a new trial. The second trial began in May in Judge Belden's court. After the case was given to the jury at 5:00 p.m. on May 6, 1886, they were unable to reach a verdict and dismissed by the judge at 11:00 p.m. A third trial began in March 1887. Although historical records are incomplete, it appears the case ended with either an acquittal or dismissal.

As an attorney, Edson often represented the downtrodden and underprivileged. Most of his cases involved small-scale civil actions and minor crimes, although he also was involved in several high-profile cases that garnered newspaper coverage.

In July 1890, he unsuccessfully defended six Chinese men who were arrested and convicted of gambling. In September 1891, he defended a fifteen-year-old boy who shot another young man with a pistol. Edson initially attempted to characterize the incident as an accidental shooting, but after the testimony of eyewitnesses, he used insanity as the basis of his defense.

Edson also practiced law on the side of the prosecution. In November 1891, he and another attorney assisted District Attorney Scheller in prosecuting two Chinese men accused of kidnapping a twelve-year-old Chinese girl from her home in San Jose's Heinlenville district. She apparently had slipped on some nightclothes and gone outside to use the outhouse when the two men allegedly abducted her.

In January 1892, Edson was the prosecuting attorney in what became known as the "spotted cow trial," so named for a cow that had been the subject of an animal cruelty charge. Edson represented the prosecution of a man who allegedly kept the spotted cow in a barren corral with an artificial stone floor and fed the animal nothing but wild thistle grass. The prosecution charged that the animal was so nutritionally deprived that it

Heinlenville was also known as "the 6ᵗʰ Street Chinatown" in San Jose from 1887 to 1931, photo circa 1900. *Courtesy History San Jose.*

was found nibbling on a barbed wire fence. Edson went as far as to bring a bunch of thistle grass into the courtroom, wave it in front of a witness for the defense under cross-examination and ask, "Is such stuff good for animals?" "No" was the reply.

When the defendant took the stand, he maintained that the cow was a stray that he placed in his corral because the animal had been feasting on his grapevines. He asserted that he fed the cow hay the entire time it was in the corral. The jury acquitted the defendant in short order.

In May 1893, an attempt was made to seriously harm or even kill the attorney. Edson had left an extraordinarily spirited horse that was attached to his buggy tied to a post at City Hall Park. When Edson and a fellow attorney were about to take a drive, he discovered that both lines had been cut through the loop that connects them with the ring in the bit. The lines still hung in position, but if the horse had started trotting at a fast clip, it would have resulted in a runaway buggy that would likely have smashed into a large pile of stones in front of the post office. Edson believed the murder attempt was instigated by someone connected to an individual who had recently threatened him with serious injury.

In March 1894, while defending a man accused of burglary, Edson nearly came to blows with a detective who was testifying for the prosecution.

Sheriff Bollinger walked into the courtroom and intervened just as both men rose to their feet and were poised to strike each other. Court was adjourned for the day.

In January 1896, Edson represented J. Heremlin, proprietor of a saloon located at the southwest corner of San Pedro and El Dorado Streets. Heremlin was charged with selling liquor to thirteen-year-old Paddy Olmstead. Edson took sympathy on the prospective juror pool of local merchants, who were concerned about being committed to a prolonged trial, and volunteered to go to trial with eight jurors instead of twelve. To the chagrin of the jury pool, the prosecution was unwilling to accommodate their desire, and Edson's request was denied.

With such an illustrious background, Juan Edson was the right man to enlist in the cause of finding James Dunham.

THE NET WIDENS

By noon on Thursday, an army of volunteers had mobilized and was scattered all over the hills. Sheriff Holbrook of Salinas had formed a posse that was heading north through the mountains. Santa Clara County deputy sheriff Rives and Officer Gordon started out from Gilroy, crossing San Isabel Creek at daybreak, believing they could intercept Dunham if he attempted to get back into the valley using that route. Constables Lovell and Hite headed to Smith's Creek from Milpitas so that the northerly avenues of escape would be covered. District Attorney Herrington and Detective Anderson acted on a clue that led them in a southerly direction. Both men were well armed.

Sheriff Ballou's hounds followed the trail near Parker's cabin as far as the creek, where Dunham may have washed his feet, and the trail was lost. After yelping and running a short distance, the dogs became confused, and it quickly became evident that they would be unable to pick up a scent from that location. No doubt frustrated, the canine manhunters were dispatched to the Smith's Creek Hotel to be on standby in case a track of a horse or a man could be found.

While others combed the hills and canyons, Edson and Bollinger decided to wait until 6:00 p.m. that evening to begin their search. If Dunham was still at large, they would survey the situation at Smith's Creek and then plot their course.

On Thursday afternoon, an exhausted Sheriff Lyndon returned to the Smith's Creek Hotel. A horse believed to be the animal belonging to Dunham's brother-in-law, Jimmy Wells, had been found running loose in Indian Gulch. The rocky canyon was situated about five miles from the hotel as the crow flies but closer to fifteen miles away due to the tortuous path that was required to reach the bottom.

A young man from Campbell who had once been in charge of horses at the McGlincy ranch was summoned to confirm the animal's identity. When the lad entered the barn at Smith's Creek where the horse was stabled, he called her by name. Upon hearing her name, Honey pricked up her ears and whinnied in recognition.

The posse had also found a tamped-down bed of leaves and twigs about fifty to sixty feet away from where the horse was found, indicating a spot where Dunham had camped the night before. The rope that had been around the horse's neck was found at this spot, leading authorities to assume that Dunham abandoned the horse so that he could make better progress across the rugged terrain.

Artist's rendering of the discovery Jimmy Wells's mare. Published in the *San Francisco Call*, May 31, 1896.

The steep ravines of Mount Hamilton provided few escape routes. *Courtesy History San Jose.*

Additionally, they found a torn piece of the *San Jose Mercury* bearing the date of May 28, the day after the murder. That edition of the *Mercury* carried the story of the murder as well as the plan to deploy bloodhounds in the hills. Authorities assumed that Dunham stole the paper from a rancher's box along the road. That information may have explained why Dunham wrapped his feet in gunnysacks to cover his scent. The gunnysacks were evidently taken from Oscar Parker's cabin. Optimism ran high that the fugitive was trapped, as there were only a few passable exits along the steep, rocky, brush-infested gulch, and all were carefully guarded.

The sheriff and his men were confident that by the end of the day, Dunham would be behind bars. Perhaps it was wishful thinking, as the alternative was unthinkable. If there was the slightest chance that Dunham could slip past the guards, get over the mountains and reach a railway station, he had ample funds to survive in the shadows of the cities below.

About an hour after the discovery of Wells's horse, a shot was heard roughly a mile and a half off in the distance, leading officers to believe the fugitive had committed suicide. Hopes of a speedy conclusion to the manhunt were dashed after a thorough search of the area revealed no trace of the outlaw. As hope of finding Dunham in Indian Gulch faded, word came in that fresh tracks had been discovered in San Antonio Valley, suggesting that the killer had passed through the gulch.

Wood Wadams on Watch

On Monday, June 1, Sheriff Lyndon returned to headquarters following an exhaustive and fruitless five-day search at Smith's Creek. His reprieve didn't last long. A report came in early that evening that Dunham had been seen again, this time at the Coe ranch, ten miles south of Indian Gulch, and also at the nearby McIlrath ranch in San Felipe Valley. The news came from a young man named Wood Wadams of Santa Clara who had heard about the sightings while visiting the area.

At 10:00 p.m. that evening, Sheriff Lyndon, Sheriff Ballou and his two fearless bloodhounds, Undersheriff S.G. Benson and Marshall Lovell of Santa Clara headed to the area. They were led by Wadams, who served as the posse's guide because of his thorough familiarity with the area.

From Wadams's account, it appeared that after Dunham's encounter with Parker and Snell near Smith's Creek on Wednesday evening, he spent the following nights traversing through the exceptionally rough country, making it all the way to San Felipe Valley. On Friday afternoon, according to Wadams, Dunham showed up at the Coe ranch in search of food. Mr. Coe had not yet heard about the murders, but he knew Dunham because he had worked on his ranch two years earlier.

Wadams told the sheriff that Coe, unware that he was now dealing with a fugitive assassin, sold Dunham some food, a rifle and thirty rounds of ammunition for the hefty sum of fifty dollars, no doubt thinking he'd driven a shrewd bargain. Dunham purportedly surfaced again at dusk the following day, this time at the McIlrath ranch. He approached a ranch hand and, claiming to be sick, offered the man money to go into the nearby town of Madrone and purchase a bottle of whiskey. The man made the trip and met Dunham around midnight with the whiskey, fetching a fee of five dollars for his work.

On Sunday morning, when newspaper stories reached Mr. Coe and word spread among the neighboring ranches, Wadams went into Santa Clara and told his story to Constable Lovell, who in turn reported it to Sheriff Lyndon. Wadams expressed his belief that Dunham was traveling on a bicycle. He claimed to have seen bicycle tracks on the trail leading from Smith's Creek. Although it had been confirmed that Dunham was at the Osgood & Smith Cyclery on Tuesday, the day of the murders, it would have been impossible for him to have hidden a bicycle in the mountains in preparation for his escape. Authorities rejected the possibility that Dunham had an accomplice who secured the bicycle in a prearranged location. It would not have made sense to attempt using a bicycle in the rocky terrain of Mount Hamilton, nor was there any evidence that Dunham was close enough to anyone who might have served as an accomplice.

On June 2, Wadams's story of Dunham being seen at the Coe and McIlrath ranches was deemed entirely false. Occupants of the McIlrath ranch and Charles Coe himself denied the entire story. Coe had not sold a

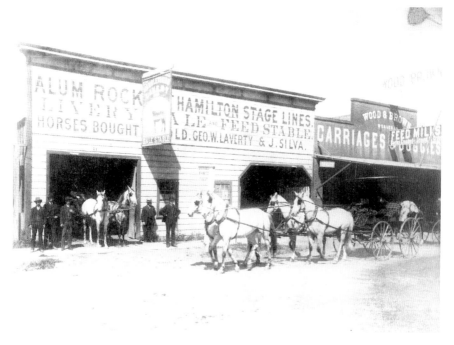

Alum Rock Livery in San Jose at the base of Mount Hamilton, circa 1895–1905. *Courtesy History San Jose.*

rifle, ammunition or provisions to anyone. Wadams apparently fabricated the yarn to draw attention to himself and possibly impress a pretty young lady he was sweet on who lived on the McIlrath ranch.

By the end of the first week, authorities were overwhelmed with reports from sheepherders and ranch workers in the hills east of Santa Clara and San Benito Counties. It was impossible for them to follow up on every story, and many, if not most, were considered dubious, as one officer explained to local reporters: "These men of the mountains are, many of them, dreamers; some of them suffering from what is commonly known as 'Shepherds Delight,' and allow their imagination to form theories, which to them soon seem realities. In this chase in the mountains the efforts of the officers are obstructed by these unreliable yarns."

Early on the morning of Wednesday, June 3, Oscar Parker, the fellow who had first encountered Dunham at Smith's Creek the day after the murders, anxiously rode his horse into San Jose to report a new piece of information. He arrived at the county jail around 11:00 a.m. In hushed tones, he related his new story to Undersheriff S.G. Benson. He'd learned that on the night of the murder, or possibly the day after, someone had stolen a loaf of bread from Sam Kitman's cabin on the Hubbard ranch, twelve miles north east of Alum Rock. Also on Saturday, ashes from a small fire were found nearby, along with some obscure footprints in the area. The officers filed Parker's story among hundreds of other reports. With his civic duty completed and relieved of his burden, Parker rode back to Smith's Creek. A week later, Parker was wanted by police after being accused of assaulting a man he had caught fishing on the Morrow ranch.

Edson Goes to Fresno County

On the evening of Thursday, June 4, after several days on Dunham's trail, Edson telephoned the Sheriff's Office from Hayes Station in Fresno County with encouraging news. He and two accomplices had reason to believe that Dunham had traveled on foot through San Felipe, caught a night train at Coyote, had gotten as far as Tres Pinos by rail and was now working his way south. Edson's posse went to Tres Pinos and then headed toward Mendota in Fresno County.

By making inquiries along the way, they learned that twenty-four hours earlier (from the time they telephoned Sheriff Lyndon), a man fitting

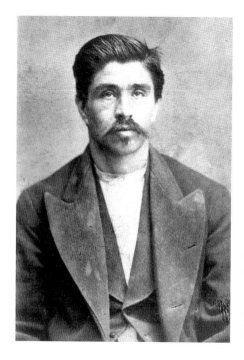

Tres Pinos, a small town in San Benito County where Juan Edson believed Dunham had passed through on his way to Mendota, was the scene of a bloody robbery at Snyder's Store committed in 1873 by legendary outlaw Tiburcio Vasquez (seen here). *Courtesy History San Jose.*

Dunham's exact description had passed through the Hayes Station area traveling on foot. The witnesses who had seen the man were not familiar with Dunham's description, yet when asked to describe the stranger, everything matched the killer, including the clothes Dunham had been wearing the day preceding the murders.

With this report, Edson and his colleagues believed they had accurately reconstructed Dunham's southerly route over the crest of the mountains, through San Benito County and into Fresno County. The theory was supported by the fact that exhaustive searches north into Stanislaus County yielded no clues, providing further support to the theory that Dunham headed south.

Edson's efforts to apprehend Dunham in Fresno County were inhibited by the fact that local authorities were unwilling to commit resources to the search. It would be impossible for three men to search such a wide area. In frustration, they headed back to San Jose and explained the situation to Lyndon, who agreed to provide additional help. After the larger group departed for Fresno, a report arrived declaring that Dunham was in King City, so the party changed course. The report proved erroneous, but by the time this was determined, Dunham had presumably traveled far away from Hayes Station.

The Trail Goes Cold

By early June, the trail had gone cold, even though the manhunt had spread across the country and into Mexico, fueled by national attention and the lure of reward money approaching $11,000. The state pledged $1,000, augmented by a group called the Citizens Executive Committee that sought to raise $10,000 in private donations from citizens and businesses. The committee decided that fundraising should be delegated to prominent ladies of the county, noting that three of the victims were women. In actuality, no one was formally authorized to release that sum. Regardless, the vague promise kept public interest high and motivated scores of professional and amateur sleuths.

On June 3, Undersheriff S.G. Benson assigned George Cottle to enlist the help of an unlikely ally in the search. The McGlincy family's old dog was said to be Dunham's only true friend on the ranch. Many believed that Dunham's dead body was somewhere in Indian Gulch, and if anyone could find it, it was this dog. It was assumed the hound's loyalty would not be diminished by the fact that his friend was a ruthless murderer. There was also the hope that poetic justice would be served if Dunham's canine companion was the one who retrieved his rotting remains. Cottle picked the dog up at the McGlincy ranch and took him to Smith's Creek. Two days later, the dog was returned to the ranch with his tail wagging in spite of his inability to locate his former friend.

As the days turned into weeks, weeks into months and months into years, the memory of the crime, along with hopes of finding Dunham, faded. Theories of the killer's whereabouts abounded. Some thought he'd hopped a train or stowed away on a ship bound for some faraway land. He had money, and there was speculation that his escape plan entailed hiding a police uniform in the hills so that he could blend in with the search party and walk away without a hint of suspicion.

Juan Edson believed that Dunham reached Mexico. Edson's theory, recounted two years after the crime, was that Dunham had traveled on foot through San Felipe, caught a night train at Coyote, got as far as Tres Pinos by rail and then traveled down to Lower California (now known as Baja California). Edson speculated that from Tres Pinos, he either worked his way along the coast, living off shellfish that could easily be found at low tide, or down the edge of the San Joaquin plains striking the coast at Ventura.

Others believed that Dunham died of a self-inflicted gunshot wound in the mountains near Smith's Creek. If not a gunshot wound, starvation and

dehydration may have killed him as he worked his way south, leaving his bones to bleach in the hot dry mountain wilderness. Indeed, about a year after the crime, human bones were discovered in the vicinity of Tassajara Springs in Monterey County. Some believed they were the bones of Dunham, while others believed they were those of a hunter who had been reported missing a year before.

A few thought he was still alive in the mountains. In the years to follow, letters arrived at the Sheriff's Office from all over the county with reports of Dunham sightings.

FALSE SIGHTINGS

In early June 1896, the *San Francisco Abend Post* received a disturbing letter from Panoche, in rural San Benito County near the Fresno County line. The letter, dated June 7, was immediately taken to the Sheriff's Office. The letter's author said that Dunham had been seen in Panoche on the fourth and fifth of the month. Accompanying the letter was a string with four dead mice tied to it, to which was appended a piece of brown paper with the following words written on it: "This is the way I did my family and this is the way I will treat you if you are there when I come around. [signed] JAMES DUNHAM."

The writing was not at all similar to Dunham's, and the sheriff dismissed it as a sick joke. It was among a continuous tide of pranks, tips and false Dunham sightings that flowed in from across the country in the wake of the killings. Days after the dead mice letter, the sheriff of Helena, Montana, pursued a tip about a man matching Dunham's description to no avail.

In July, a man resembling Dunham who gave the name of Frank Dalton was arrested in Fargo, North Dakota, and sentenced to thirty days in jail for stealing a bicycle. Although he admitted to giving authorities an assumed name, he emphatically denied being the killer. After he was photographed and a print was sent to San Jose, he was cleared.

In early September, a prospector named W.D. Henry was suspected of being Dunham and arrested in the mining town of Ouray, Colorado, even though he insisted he hadn't been in California in more than ten years. He, too, was photographed and cleared.

In October, three bank robbers were fired on by armed citizens and riddled with bullets in Meeker, Colorado, while attempting to flee with

$700 taken from the bank's vault. In the immediate aftermath of what was called the most daring bank robbery ever attempted in the West, it was reported that one of the dead robbers was Dunham. The report was later deemed false.

AN INCONCLUSIVE END
TO A CENTURY

1897

National interest in the hunt for James Dunham remained high as 1896 came to a close. Bounty hunters, law enforcement agencies and concerned citizens from coast to coast continued to come forward with leads that would inevitably prove fruitless. On March 1, 1897, a man giving the name Herman Dandy was arrested near Spokane, Washington, on suspicion of being Dunham. He was not the killer. On April 12, a homicidal maniac in Stockton was mistakenly identified as Dunham after being arrested for chasing a co-worker nearly four miles with the intention of mangling him with a knife.

In July, a man from Oakland named A.M. Stoddard walked into the office of San Jose police chief Jason Kidward with a strange story. He claimed to be acting on behalf of a friend who was an engineer on one of the ocean streamers that was presently docked in San Francisco. According to Stoddard, the friend had known Dunham personally before the infamous murders had been committed and had recently encountered the killer in a foreign port. Stoddard's friend said Dunham was engaged in a small business under an assumed name and had significantly altered his appearance. Pressed by Kidward for details, Stoddard insisted on first being paid $1,000 in cash, with an absolute guarantee that the remaining $10,000 would be paid if Dunham's whereabouts were revealed. The chief

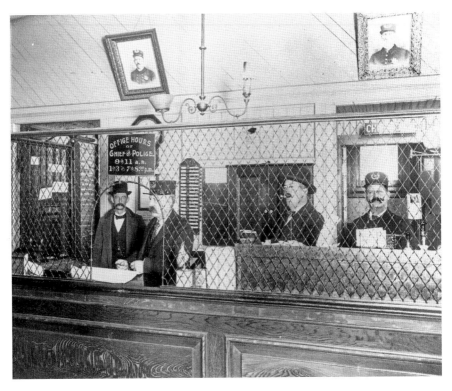

San Jose police chief Jason Kidward (*second from right*) had serious doubts that Dunham escaped the country by stowing away on a steamer. This photo, circa 1895, was taken at the police desk at San Jose City Hall. *Courtesy History San Jose.*

could not make that promise and appealed to Stoddard in the interest of good citizenship. Stoddard promised to discuss the matter further with his confidential source and left the nearly three-hour meeting without divulging the name of the engineer, the name of the steamer, the name of the country or port where Dunham was said to be residing or the nature of his business. Stoddard never returned. Kidward was left strongly doubting the credence of the story.

In October, a year and a half after the crime was committed, a grand jury in San Jose finally issued a formal indictment of Dunham for the murders. The glacial pace of the grand jury's deliberation may have taxed the patience of friends and families of the victims, but this also served to keep the story in the news and in the forefront of public awareness. The same month that news of the indictment hit the papers, two more Dunham sightings were reported.

The first involved a man resembling Dunham who was arrested near Mazatlan, Mexico. The description matched, but a photo sent to San Jose did not. The second report prompted Santa Clara County deputy sheriff George Cottle, who had known Dunham since boyhood and had been with him the day before the murders, to board the steamer *City of Paris* in San Francisco bound for Rosario, Mexico. Cottle's mission was to verify the identity of a man arrested there who was thought to be Dunham. The man was not Dunham, and while Cottle was gone, a barn on his San Jose property burned to the ground. His wife, concerned the fire would spread to the family home, fell down the stairs and seriously injured herself while evacuating her second-story room.

In November, Police Chief Kidward received a message from a John Hortis of Pine Bluff, Arkansas, that noted, "Is James C. Dunham still wanted there? If so, state reward and telegraph description; wire answer immediately." Kidward turned the communication over to Sheriff Lyndon, who immediately replied in the affirmative and mailed a description and photograph. Apparently, the tipster was hoping to cash in on the apprehension of a suspect in another part of the state. Later that same morning, Lyndon received a message from Van Buren, Arkansas, with information about a suspect being held there. The prisoner was said to be of a reticent nature; however, he had admitted to being engaged in the nursery and grocery businesses in the past, both of which were occupations once held by Dunham. It turned out that a similar occupational history was the only thing the prisoner had in common with the California fugitive.

In December, a bounty hunter named S. Comstock, well known in the lumber business around San Jose and Fresno, headed for the Yaqui country in Mexico, equipped with photos, in search of Dunham, whom he believed was hiding in the area. Another year may have been coming to an end, but the hunt for Dunham was not.

1898

In January 1898, police in Boston and Greater New England were on the hunt for Paul Muller, wanted for the brutal murders of his wife, Francis Newton, and his adopted daughter in Brockfield, Massachusetts. Authorities believed that Muller and Dunham were the same man. Muller fit the description of Dunham, had a similar occupational history and, like Dunham, had used

an axe to crush the skulls of his victims. Moreover, there were reports that Dunham had been seen and recognized in Boston by a former friend in June of the prior year. Muller was never captured, but ample evidence surfaced indicating that he was not the killer wanted in California.

In August, another Dunham trail came to a peculiar end. Months earlier, there had been Dunham sightings in the mountains near San Bernardino, prompting law enforcement officers from Los Angeles to launch an exhaustive search in hopes of claiming the $11,000 reward money. After many months, their efforts were abandoned after learning from multiple parties that the mysterious mountain man did not fit Dunham's description. Shortly after that, the man was apprehended by authorities from Calabasas, and dispatch was issued from Los Angeles:

> *After eluding the officers for more than three months, Jose Maria Maltiz, known as the "Hermit of the San Bernardino Mountains," was placed in the custody of Sheriff Burr by Constable Branscomb of Calabasas. Maltiz is one of the queerest characters in the State, with his long, grizzly hair, sun-blackened features, and feet that have worn no shoes for many long months. No one knows him further than to see him occasionally when he was forced to go to a farmhouse for food. This was never denied him, for he invariably accompanied the request with a threat.*
>
> *Although a Mexican, he seems to entertain a special grudge against his countrymen. Some time ago he chopped one of them in the breast with an ax it is said, and then lapped the blood from the wound. The hermit has been a migratory creature, for at least two dozen huts of gunny sacks and cactus stalks have been put up by him over the mountains, as he changed his abode nightly.*
>
> *To this fact is attributed the difficulty in capturing him. Maltiz fought the arresting officer with desperation. To a reporter he said he was a fugitive from Mexico, where he had killed two men, and that he had been living in the San Bernardino Mountains for over ten years. The old man will be examined by the Lunacy Commission.*

In October, the purser of a ship that arrived in San Diego reported that a man answering the description of Dunham had been seen in Lower California. The vagueness of the tip rendered it inactionable.

That same month, Lyndon's attention was diverted to a different search in the same area where Dunham had initially fled. Lyndon and Undersheriff Benson went to Mount Hamilton near Lick Observatory to search for Ben

Wandell, the missing son of local rancher Jake Wandell. The son had been alone at the ranch while his father was visiting downtown San Jose. The father returned late on a Saturday afternoon to find a large spot of dry blood on the floor in the middle of the cabin and evidence of a bullet that had broken a window upon entry and left a hole in the door upon exiting. There was no sign of the son and no signs of disturbance other than the blood and bullet passage. A two-day search of the mountains yielded no sign of Ben. It was not the first time Sheriff Lyndon came up empty-handed in a mountain search.

1899

In the midst of the ongoing Dunham search and day-to-day crime-stopping activities, the Sheriff's Office was in a state of transition in 1899. Following the previous November's election, Lyndon departed as sheriff. He had run for reelection as an independent candidate and lost to Republican Robert Langford. Despite securing the endorsements of the Good Government League, the Populists and even Fred Tennant, whom many thought would run as an independent against Lyndon, the incumbent sheriff came up 151 short in the final vote tally. Lyndon unsuccessfully contested the election results, alleging that some number of votes counted in favor of his opponent were illegal and that others should have been counted in favor of him.

Lyndon's departure had a tragic impact on one of his deputies, Augustus F. Allen, who lost his job when Sheriff Langford took office. Allen was popular among local peace officers and was known for his kindly, jovial disposition. By late March, the loving husband and father of five young children was growing despondent over his bleak employment prospects and dwindling funds. One morning, he left his home in search of employment, stopping back at home for lunch and heading back out that afternoon. He returned home around 5:00 p.m., unsuccessful once again. At 6:00 p.m., he handed his wife a dollar bill and told her it was the last one he had. He then went into the bedroom, stood in front of the mirror and fired a shot that passed entirely through his head, leaving him bleeding profusely and shattering the plaster in the wall across the room. Within the hour, he was officially pronounced dead in his home.

Sheriff Langford's dismissal of Allen was probably not personal and certainly not unusual. Managerial shakeups and acts of patronage

accompanying regime changes are embedded in American political institutions at every level of government. Voluminous records and newspaper accounts of Robert Langford portray a man of character, compassion and competence.

The new sheriff came from a long line of pioneering families. His ancestors were among the earlier settlers of the Jamestown colony dating back to 1668. They also fought in the colonial and Revolutionary wars. Sheriff Langford was born in Washington County, Iowa, in 1851. With his parents, Pleasant and Sarah Langford, and four siblings, he crossed the plains with ox teams to California in 1852. They came directly to, and settled in, the vicinity of Bainter's Gulch near Los Gatos.

Langford attended the public schools of Los Gatos and graduated from the University of the Pacific. In 1876, he married Francis Freeman, a native of Illinois. The couple purchased ten acres on Senter Road in 1886, planted cherry and apricot trees and had three children. For twenty-two years, Langford was in the butcher and cattle business while running a very successful meat market on First Street.

In January 1899, the *Oakland Enquirer* reported that Sheriff Lyndon, before leaving office, had pursued a theory that Dunham had boarded a seal boat, the *Sophia Sutherland*, that had been docked in Antioch and sailed to Alaska. Such a vessel would be an unlikely place for a fugitive to be noticed, and customs law did not require seal ships to make out a manifest of their passenger lists. If Dunham had been a passenger, it would not have been a matter of public record. The new sheriff concluded that there was insufficient evidence to pursue that line of investigation and directed the investigation toward other leads that continued to trickle in.

In February, Langford received a letter from a D.J. Bovet of Raburg, South Carolina. Mr. Bovet was certain that a member of the Raburg police force whose last name was Bunham was, in fact, James Dunham. A quick inquiry determined that Bunham was not Dunham.

In August, police in Louisville, Kentucky, apprehended a morphine addict who bore a strong resemblance Dunham. The man said his name was C.F. Netterfield and that he was from Warren, Ohio. After Louisville chief of detectives William J. Sullivan sent Sheriff Langford a photo of his suspect, he received this telegram reply: "Your suspect has strong resemblance to Dunham. Hold for further investigation. Has he a scar in the edge of hair over his right ear?"

As soon as the message was received, Louisville detective Tom Check went with three other officers to investigate the prisoner. After a close

investigation, they were convinced that they found the scar, even though it was barely visible.

Santa Clara County deputy sheriff Bob Anderson excitedly began preparing for his trip to Louisville to identify the suspect. He spent the entire day of August 13, 1899, overhauling his wardrobe and rehearsing his anticipated interview with Governor Gage regarding when he should apply for the requisition papers. Several of his envious colleagues gave serious consideration for paying Bob off for the chance to take his place.

Eventually, however, the veracity of the prisoner's story and true identity were confirmed. He was indeed simply C.F. Netterfield, a hopeless dope fiend from Ohio.

GRUESOME RELICS

By November 1899, Sheriff Langford had become settled into office and the curator of a collection of relics assembled from multiple crimes of days gone by. Assisted by Deputy Sheriff Bache, the articles were maintained as an exhibit that included weapons used by various murderers to kill their victims.

Among the relics was a blade used by a man named Baptist Sandoval to kill a Mr. Uzeta in 1876. The two men had been arguing over who had the blackest blood. To prove the matter and end the debate, each agreed to let the other cut his hand slightly and draw blood. Uzeta's knife cut too deep, and in an instant, Sandoval's knife was buried in his throat.

The collection also included a gun used by a man named Brutinel to kill a man named F. Brown, along with a spoon Brutinel subsequently fashioned into a knife and used in a failed suicide attempt while in jail. Brutinel was deemed insane and spent his final days as a resident of the Agnews State Hospital, known at the time as the "Great Asylum for the Insane," in the city of Santa Clara.

The Chinese were well represented in Langford's chamber of horrors. Among the opium pipes and knives in the cabinet display was an early Chinese "coat of mail," which was simply a jacket stuffed with layers of Chinese paper for the purpose of slowing or deflecting bullets. Langford and Bache were actively working to locate and secure an example of a more current coat used by the Chinese made of steel.

There was also an improvised saw, made from a case knife by famous highwayman John Brooks, who with his partner robbed a gardener at

The Agnews State Hospital, circa 1890s. Established in 1885, Agnews was originally known as the "Great Asylum for the Insane." Programs for the mentally ill were discontinued in 1972, and the facility was closed in 1998. *Courtesy History San Jose.*

Edenvale one night on Monterey Road. The two were sentenced to hard time in San Quentin. There was a rifle used by Thomas Flannelly to kill his father and Sheriff McElroy in San Mateo in 1898. And there was the pistol used by James Dunham in the McGlincy killings in Campbell in 1896.

A Skeleton

Later in August 1899, sixteen-year-old Fred Keeler and his friend Clinton Jones were pedaling their bicycles over Pacheco Pass on their way to San Jose from their home in Visalia. Suddenly, a tattered rag blowing in the wind near the trail caught Fred's attention. He stopped, got off his bike and walked over for a closer look. What he saw horrified him. Lying in the weeds was a human skeleton wrapped in a gray blanket. The person's clothing had long ago rotted and blown away, yet a piece of cloth remained

Pacheco Pass photo from 1935. In modern times, Pacheco Pass is a busy corridor connecting the South Bay Area to the Central Valley. The passage was much less traveled prior to the latter half of the twentieth century. *Courtesy History San Jose.*

wrapped around the skull, possibly a bandage that had been used to cover a wounded cheek.

Shocked and terrified, Keeler and Jones jumped on their bicycles, rode into Gilroy and reported what they had seen. Because of their haste, frightened state of mind and unfamiliarity with the little used trail through the pass, they were unsure of the exact location of their sighting. Accompanied by Sheriff Langford and Deputy Sheriff Rives, the boys attempted to retrace their route, hoping to recall where the skeleton was found. Langford was confident that if the skeleton was retrieved, it would be easy to determine if it was Dunham. The killer's former dentist, Dr. W.A. Gaston, had given the sheriff a detailed description of Dunham's fillings. Unfortunately, the mysterious skeleton was never recovered.

A Skull

In November 1899, the *San Diego Union* published a report on the travels of Colonel William Denton, a well-known mining man who had recently returned from a long sojourn in Lower California. The purpose of his trip was to collect and examine copper deposits that had been reported.

Denton's adventure began in July, when he traversed across the desert wearing only a light shirt, linen trousers and shoes. Upon reaching the Gulf coast, he and his three companions procured an old, flimsy canoe that had been patched up many times by its previous owners. At one point, several miles offshore, the canoe nearly sank when a large sea turtle the crew had captured punctured the bottom of the vessel. The men were able to patch the leak with a piece of canvas and return to shore, but the turtle escaped.

The specific copper deposits Denton had set out to investigate proved to be worthless; however, he discovered other copper deposits that proved to be exceptionally rich. Some specimens were 84 percent copper. A more interesting, if gruesome, item Denton brought home was a skull that allegedly belonged to James C. Dunham.

Denton's belief that the skull was Dunham's was based on the fact that shortly before the grisly murders in Campbell were committed, Dunham and his brother had gone to Dulzera near the Mexican border to take charge of their father's ranch following his sudden death. Several Dunham sightings in the area had been reported after the murders were committed.

One came from Don Emiliano Ibarra, a resident of the nearby Hansen cattle ranch who in the summer of 1898 had met a man hiding in the brush. The stranger declined Ibarra's invitation to spend the night inside the ranch house, but during the course of the conversation, he asked Ibarra if ships bound for Europe sailed from Santa Rosalia on the Gulf coast. Ibarra told the stranger they did.

Ibarra was later recounting his conversation to a group of Mexicans at the ranch that same evening when one of them, Tircio Martinez, produced a photo of Dunham. Ibarra confirmed the man in the photo was the same man he had met earlier that day. The following day, Martinez started on the trail of Dunham and ultimately traced it to a cave on the coast of Lower California, where parts of a man's dead body, including remains of a head and a blue-and-white striped necktie, were discovered.

During Colonel Denton's visit to the area, Martinez told him of the discovery and the head. Denton, in turn, recovered the skull and tie, notified Sheriff Langford and had the items sent to Santa Clara County. According

the *San Diego Union* dispatch, the lower jaw was missing, and no teeth remained in the upper jaw. The teeth were believed to have been lost in the cave. If Denton had known the teeth would be valuable in identifying the remains, he could have recovered them.

For weeks, the ghastly relic sat on top of a big safe in the sheriff's office. After having the skull examined by multiple experts, Sheriff Langford, who had by then fielded countless false reports of Dunham sightings, dismissed the report. The skull had been in a severe state of deterioration, and most of the teeth, essential for identification, were missing.

MISTAKEN IDENTITIES

A BODY

In August 1900, a laborer named Frank Higuera was erecting a barn on the Grant ranch, about five miles above Alum Rock Falls and not far from where Dunham had been sighted hours after the killings in May 1896. It was about noon when he spotted a deer, grabbed his rifle and pursued the animal into the woods. About fifty feet from the wagon road, he discovered a body lying in the brush that he believed represented the remains of James Dunham. Wanting to preserve any chance he may have had at claiming the reward money, Higuera consulted an attorney to learn the conditions of the reward offered by the State of California and the Citizens Executive Committee before reporting his find to the police.

Word of Higuera's discovery leaked, and rumors quickly circulated that the body of James Dunham had at last been recovered. Because Coroner Kell was ill the day the body was reported, Justice Wallace acted in his stead, accompanied by Deputy Sheriff Bache and San Jose police chief Kidward. The men went to the spot of the sighting and viewed the remains.

They determined that the man had been dead five or six months. The body was clothed in a brown sack coat and brown vest. A soft brown hat and pistol were found nearby. In the center of the forehead was a bullet hole that appeared to match the bore of the pistol. There was an abundance of light-brown hair on the head. Several of the front teeth were missing, but some of

the back teeth had been filled with amalgam. No papers were found on the body, but there was a purse in one of the hip pockets containing two half-dollar coins, one minted in 1894 and the other in 1897. Because the latter was minted in the year following the manhunt of 1896, the possibility that the body was Dunham's was cast in serious doubt. An inquest held at the undertaking rooms of WB Ward & Company confirmed that the remains were not Dunham's, and the unidentified man's death was ruled a suicide.

THE CURIOUS CASE OF CHARLES CRILL

On May 1, 1901, Charles Crill sat in the San Jose jail as more than one thousand curious people came by to inspect him. He had been escorted to San Jose by Santa Clara County deputy sheriff Bache, who had traveled to Wichita, Kansas, and made the arrest at 2:00 a.m. the week before because Sheriff Langford was ill. Crill was suspected of being James Dunham and was charged with the McGlincy murders.

The subject was asked to walk, talk, stand and sit by the many observers who were called to identify him. Crill willingly took it all in stride. "The more they see of me, the sooner they will know that I'm not Dunham."

All agreed that the accommodating, agreeable and talkative prisoner who sat in his cell looked nearly identical to James Dunham. Yet to the hundred or so who knew Dunham the best, and who scrutinized the prisoner most carefully, it was abundantly clear that although Crill was approximately the same height, possessed the same thumbs and walked the same way as Dunham, this was not man who had committed mass murder in Campbell five years earlier.

Crill, a native of New York, moved to Illinois as a young man and began working various jobs in that state, as well as in Missouri, Colorado, Nebraska and Kansas. It was in Wichita that Crill's misfortune began. He had been staying at a local residential hotel where he met a fellow resident, E.F. Greiner, a former police chief from Burlington, Massachusetts, in a nearby saloon. One night, while drinking heavily, the two men got into a fight with members of a gang that Greiner had run out of Burlington years before. Greiner was not hurt, but Crill suffered a broken nose and a black eye and had two front teeth knocked out. For two weeks afterward, the two of them drank together each day as Crill convalesced. Greiner expressed remorse to Crill for involving him in the fight and even promised to pay his hotel bill.

What Crill did not know, however, was that during this time, Greiner had sworn an affidavit stating that Crill had confessed to the murders committed by James Dunham. It was not until Crill had been arrested and taken to San Jose that he learned that his Wichita drinking companion had betrayed him.

Langford was nearly certain that he had Dunham in his custody. On the evening of May 6, he told reporters, "I have considered all that the day has brought forth and I remain of the belief that my prisoner is the Campbell murderer. True, I may be mistaken. I was aware when I served the warrant of arrest that in such a case there was bound to be an element of doubt. But if I am mistaken, and I see no good reason to think I am, then we have run across one of the most wonderful examples of similarity of men which has ever been recorded."

Henry Miller, the stationer who once employed Charles Dunham, was another who unwaveringly declared that the right man was behind bars. Miller had known James Dunham for years and was considered a man of intelligence with a conservative demeanor. When Langford asked him to scrutinize the prisoner, he told Miller to take as much time as he needed and make no mistake. Following his visit, Miller looked Langford in the eye: "Lock him up and have no fear—you have arrested Dunham."

A.B. Post, assistant cashier of the Garden City Bank and longtime Dunham acquaintance, was equally convinced. "If that man were to come into our counting room, I'm so sure he's the person the sheriff says he is that I'd be inclined to drop my pen and run."

Howard Buffington, who perhaps was most qualified to identify Dunham, having been in his company mere hours before the murders, had no doubt: "He is no Crill—he is Dunham."

There was also, of course, the story and sworn affidavit of E.F. Greiner, who in addition to his credentials as a former chief of police was claiming the $10,000 reward. The affidavit noted, "That he, C.F. Crill, at Santa Clara County, did kill the McGlincy's, and after so killing them did flee to Mexico."

But more voluminous and compelling statements came from those who disagreed. Former friends, employers and acquaintances of Crill, as well as Crill's two ex-wives, corroborated the details of his past residences and occupations. At the same time, dozens of people who knew Dunham well before the murders—including his barber, co-workers, roommates, classmates and employers—came forward to insist that although the resemblance was strong, Crill was definitely not Dunham.

"The case affords an example of wonderful similarity between two persons in no way related I should say," was how a former acquaintance

of Dunham's, W.E. Dent, expressed it after a careful examination of the prisoner. "I knew Dunham well enough, I think to identify him anywhere, and I must say that this man would attract my attention as resembling Dunham, but the resemblance is in a number of details rather than general effect."

Those details were indeed numerous. To render clear the resemblance between the prisoner and the murderer, authorities compiled a comparative set of characteristics with comments that was provided to the media

POINTS OF SIMILARITY IN CRILL'S APPEARANCE AND DUNHAM'S

	JAMES C. DUNHAM IN 1896	CHARLES F. CRILL IN 1901
Height	5 feet, 11½ inches	5 feet, 11½ inches
Weight	165 or 175 pounds	about 185 pounds
Age	32 years	(stated) 41 years
Eyes	blue	blue
Eyelashes	long and black	long and black
Teeth	one front one filled	corresponding tooth and another front one gone
Nose	broken, turned toward right	broken, turned toward right
Complexion	clear	tanned
Hair	dark brown	dark brown, tinged with gray
Moustache	dark brown	dark brown, tinged with gray
Scars	trace of knife wound on back of neck, toward right side.	trace of knife wound on back of neck, toward right side.
Thumbs	end joints peculiarly short and stubby, so that they seem deformed.	end joints peculiarly short and stubby, so that they seem deformed.

	James C. Dunham in 1896	Charles F. Crill in 1901
Size of Shoes	no. 9	no. 9
Peculiar Habits	used to push his hat back when intently conversing; his chin receded when he laughed	pushes his hat back when intently conversing; his chin recedes when he laughs
Handwriting	excellent and plain	excellent and plain
Nationality	American	American
Language	understood Spanish	is said to understand Spanish but denies it

Former Dunham classmate I.A. Spinelli spent a half an hour with the prisoner: "I have looked at him carefully, and while I see points of resemblance, there is something lacking. I do not believe the prisoner is my old schoolmate Dunham."

Crill steadfastly insisted that not only was he not Dunham, but that this was also his first trip to California. To a large extent, it was the corroboration of details surrounding his claims of residing in Rockport and Pueblo, and being married in Colorado, that ultimately validated his innocence. George A. Seely and Mrs. Annie Blonquist, residents of Rockport during the time Crill claimed to live there, after questioning the suspect, announced that there could be no doubt that he showed an intimate knowledge of the Illinois town and key events that had transpired in it during his purported residency. In particular, he was able to name the date of a major fire that occurred there and described in detail many incidents that only an eyewitness could have known.

C.H. Shumate was a grocer from Pueblo, Colorado, who knew the family to which Crill claimed to have married into. His questioning convinced him that the prisoner had lived in Pueblo and possessed extensive knowledge of each family member.

The testimony of Father Leggio, a Jesuit priest from Colorado, provided perhaps the strongest and most striking evidence that Crill was not Dunham. Upon entering the prison office, the priest did not announce his name. He buttoned up his coat to hide the cloth of his calling, donned a borrowed hat and began interviewing Crill. Leggio methodically questioned Crill about his life in Colorado up until his wedding in 1887. Crill spoke in detail of people

he knew there and then explained that a Father Leggio had performed the ceremony in his wedding to Dora Schreiber, a young lady who sang in the choir of St. Patrick's Church. Crill noted that the ceremony was held in the church annex and that a Miss Devereaux acted as bridesmaid.

Father Leggio noted, "I did not recognize the man as the person who had been the groom in Pueblo, but I led him on to tell me about the ceremony and the incidents surrounding it, and he spoke of a number of details in such a way as persuaded me that he was indeed the person he claimed to be."

The priest also noted that as he was about to leave, he asked the prisoner if he would recognize Father Leggio if he saw him, to which Crill responded, "Well, if Father Leggio has a double, you must be him." At that point, the interrogator removed his hat and coat and, with a twinkle in his eye, clasped the prisoner's hands. Now convinced that Crill was who he said he was, the two men shared recollections of the wedding day. Crill was not a Catholic, and in order to have the marriage performed in Dora Schreiber's parish church, a dispensation from the bishop at Denver was necessary. It was late in arriving, and the marriage had to be postponed from the morning to the afternoon. Father Leggio and Crill had made several trips to the telegraph office to get the permission, and Crill paid the five-dollar fee. Crill was assured that his marriage record could be found in the St. Patrick Church records in Pueblo.

On May 11, 1901, two weeks after arriving in San Jose, Crill was finally set free.

BOUNTY HUNTERS, TIPSTERS AND SCAMMERS

TRUANTS AND MOUNTAIN MAN

On the morning of June 15, 1901, Sheriff Langford got some unsolicited help in the search for Dunham from three east San Jose boys whose ages ranged from thirteen to fifteen. Charles Fisher and brothers Ed and William Gruell, tired of the dull routine of school life, announced to several of their friends that they were setting out to track and catch the Campbell murderer, James Dunham.

The boys were well equipped for the adventure. One of them stole his father's watch and bicycle and traded them for a donkey. Another borrowed a cart from a neighbor in which they loaded three axes, three hammers, two guns and a supply of jam they filched from a family storage pantry. The sheriff was notified and apprehended the youthful bounty hunters about a dozen miles from their homes. They were returned to their parents.

In June 1902, a San Francisco paper reported that Dunham might have been residing in the forest near Boulder Creek in the Santa Cruz Mountains. A cabin that could only be accessed by rope or ladder was found in a remote section of the forest known as the Cowell Timberlands. The cabin had very recently been vacated, and several locals believed it had been occupied by Dunham. On May 27, H. Duvall, foreman of the Cowell reservation, was prospecting for timber when he saw a column of

smoke rising from a level spot on a precipitous slope that fell away to a ravine approximately ninety feet deep.

Thinking it might be the lodge of a hunter, he called across the ravine. There was no response, but the column of smoke suddenly disappeared. Duvall then made his way to the face of the plateau just in time to see the end of a rope ladder being drawn up and over the top of the cliff.

Startled, Duvall then left the area. A week later, he shared his story with Charles Hartman, a former miner who owned a card house in the neighborhood. The two men formed a search party and returned to the remote plateau. At the bottom of the cliff, below the plateau, they found the rope ladder hanging motionless. Hartman began climbing it, but after ascending about twenty feet, the rope broke and he fell, suffering serious bruises.

Members of the search party took him home and then returned with hatchets and iron pegs, which they used to cut steps in the rock and safely reach the top of the plateau. The plateau was about a quarter of a mile wide and covered with a dense growth of chaparral from six to nine feet high. After crawling on their hands and knees for approximately two hundred yards, the men reached a cabin. It was situated in a slight depression in the ground, made of "rough-hewn slabs" and painted a vivid green that blended in with the surrounding vegetation, making it nearly impossible to discern from a distance.

The door was broken, but no one was inside and everything was in perfect order. The cabin was furnished with a gasoline stove and oven, flour and canned fruits, a few dead quail and a dead rabbit. Also present were a number of books and a complete file of articles from a San Francisco newspaper chronicling the McGlincy murders and the search for Dunham from the time of the crime up until May 27, the day Duvall disturbed the occupant. The mysterious mountain man was never found or identified.

EDSON RETURNS TO THE TRAIL

Also in June 1902, Juan Edson, now a former San Jose peace officer living in Los Angeles, was once again hot on Dunham's trail according to a dispatch from Tucson in the Arizona Territory. The renowned sleuth was following up on a lead that the fugitive was living among the Yaqui tribes. In a statement published in the local papers of San Jose and Arizona, he

said Dunham was as good as captured and would be in custody within ten days, two weeks at the latest.

Edson's lead this time initially materialized while he was in Sonora working on a divorce case. He had asked friends in the area to be on the lookout for Dunham, and this led one of them to report a Dunham sighting in the Sierra Madre Mountains, three hundred miles by trail from the nearest station on the Sonora railroad. Edson enlisted the help of a trusted Mexican guide to help him navigate the vast and rugged wilderness and elude the notorious desperadoes who occupied the area. Edson believed that Dunham had been living with a band of Navajo Indians for a number of years.

After three weeks in Mexico, Edson returned to San Jose empty-handed but silent about the results of his mission. His close friends speculated that he had located Dunham and was in the process of investigating whether the reward that could be collected would cover the expenses incurred during his search. If Dunham was among Indians, it was thought that both a legal and physical fight could be expected.

On July 12, 1902, a tongue-in-cheek article appeared in the *San Jose Evening News*: "A Correspondent suggests that it may be that the snake that chased Rancher Adams near Mount Hamilton may have eaten Dunham. This might be investigated before Juan Edson makes another trip to Mexico in search of the fugitive."

A Botched Reward Scam

On August 1, 1902, the Governor's Office in Sacramento received a poorly written, almost incoherent letter from a sleuth in Norton Heights, Connecticut:

My Dear Sir

A year ago I.C. Gannon of Cincinnati, Ohio, appointed me as detective to hunt one James C. Dunham or Walter Bassett is the right name. J.C. Dunham is the murderer of Mrs. R.P. McGlincy, Mrs. Hattie B. Dunham, Miss Minnie Schesler, Colonel R.P. McGlincy, James K. Wells and Robert A. Brisco in 1896 near Campbell, Santa Clara County Cal, which a reward of $1000 was offered by the governor and additional reward by the citizens of Santa Clara County will give $10,000 for the

capture dead or alive of James C. Dunham alias Basset which the photo of James C. Dunham is exactly like one Walter Bassett who is known in this section as Walter Bassett. This description and age, height, complexion, weight, features, hair, mustache, everything is exactly the same as Bassett and Dunham are exactly the same.

I was to get 25 per cent, would be $2600. I suppose you know that James Teeley went to California to collect the reward of $11,000. If he did collect it I did not receive my $2600. It may be it was not paid. If not I am the one that found that Dunham and Bassett is the same person. The man is now at large in Massachusetts. If I wish to find him I could find him at once, but as I have been to a good deal of trouble tracing him out and making sure that Dunham and Bassett are both one if you wish to get him send a man here and I could give all information you wish to find the man. I know him. He is a desperate man. He offered $1000 to have me killed but I have a brother who is in the 33rd degree Masons. He told the Masons what to do and Bassett dare not say a word afterward. He had his orders to keep still. I am up to 19 myself.

If anything is done it must be done very carefully, and my name must not be made public, must be confidential, and I ought to have the reward in full if it has been or has not been paid.

Hoping to hear from you soon about the reward.

J.N. Wilson.
P.S.—I am a detective.

El Renegado

During that same year, 1902, trouble was brewing in Sonora, Mexico. A revolutionary known as El Renegado was stirring a Yaqui Indian rebellion against the Mexican government in the cities of Guaymas and Hermosillo. El Renegado told the Yaquis that the Americans were their allies and would defend them against the rifles and lances of their Mexican oppressors. The emissary of the Yaqui insurgents focused his recruiting efforts on impoverished soldiers of fortune who were enamored of his eloquent vision of conquest and promises of wealth.

Battling a state of constant terror, the police of Guaymas and Hermosillo made nightly raids on suspected rendezvous of conspirators, searching for

arms and evidence of treasonable hostility. In one Yaqui home, they found a small American flag nailed to a wall. Beneath it was an inscription that read "Death to Porfirio Diaz," in reference to the entrenched president of Mexico whose repressive policies precipitated the Mexican Revolution.

A theory emerged that El Renegado was none other than James Dunham, due to the fact that he was ably assisted by a thirteen-year-old girl from the killer's hometown of San Jose. Little Dietta James had been brought from California and roused to fanatical fury against the Mexican government by Santa Tersesa, a companion of El Renegado. Shouting treasonous slogans such as "Down with Mexico!" and "Long live the Yaquis and the Yankees, forever allied!" the little girl would dutifully distribute small American flags to enemies of Mexico.

During a trip to New York and Chicago to secure money for the revolution, Santa Teresa left Dietta in the custody of El Renegado, who enlisted her as a spy. The girl would smile sweetly while innocently questioning enemies of the rebellion and then relay her intelligence findings to El Renegado. Eventually, Dietta's espionage activities caught the attention of the Mexican police, who tracked her down at the Hotel Central of Guyamas. El Renegado had fled, and she was alone when police apprehended her. Because of her youth and persuasive innocence, she was not arrested; however, she was kept under strict surveillance. The authorities also tried to induce her to betray her co-conspirators by combining clever interrogation techniques with promises of rewards, to no avail.

The police believed that El Renegado had returned to the Yaqui country, but after intercepting a letter he wrote to Dietta and posted at Magdalena, a small town a few miles south of Nogales, they learned that he had headed north and was intending to cross the American border.

More Leads, No Luck

In April 1903, another false Dunham arrest occurred. This time, it was a man arrested in Butte, Montana, for burglary. The suspicion was quickly dismissed.

In January 1904, Sheriff Langford received a letter from Lupe Marron, who resided on the old Dunham ranch in Dulzera. Marron's letter mentioned a strange and mysterious wild man who was making his home in the hills in the area and whom he thought may be James Dunham. Before moving to

Santa Clara County, Dunham had lived on his father's bee ranch there and knew the country well.

Langford wrote Marron back, asking for full details, and received this reply:

Sheriff Langford…

Dear Sir: Having received your letter asking for information of the strange man that is in this part of the county, I do not know that it is James Dunham, but I think it is. He is such a wild, shaggy man I think it is hard to tell. I am living on the old man Dunham's place and have seen Jim Dunham, but it was long ago.

This man has been around here three or four years, but no one can get close to him. I have been on the lookout for him and have seen him twice. He has a sandy beard that looks like it was faded. He looks like a man about six feet. He has a large foot by the track. His clothes are all rags tied up with strings. He wears an old overcoat at times. If he sees anyone, he runs into the brush and hides and does not come out. I think he must travel through the brush and mountains to or across the line, which is not far from here.

He will not speak to anyone if they speak to him, but gets out of the way as soon as possible. I have not seen him for about a month. It would be impossible to track him, for he has rawhide tied around his feet and seldom steps out on the trail. In riding through the mountains looking for stock I might run on to him again. I think I could capture him if I could once get sight of him again.

LUPE MARRON.

In April of that year, officers in Tia Juana (now San Ysidro, California, not to be confused with the town of Tijuana across the border) shot and killed an alleged outlaw who was believed to be the same man Marron wrote about. However, by May, no efforts were made by Tia Juana authorities to notify Sheriff Langford, even though reward money for Dunham's capture was still unclaimed and in play.

In May 1904, it was brought to the attention of Sheriff Ed Cudlee of Seattle that the crime committed by a man he was now holding in custody was very similar to a crime that had been committed in Santa Clara County eight years earlier. And the alleged perpetrator being held for the murder

of his wife and family happened to be named either Dunham or Derham. The sheriff couldn't be sure, but on May 25, one day before the eighth anniversary of the infamous Campbell murders, he telegraphed Sheriff Langford. Once again, however, the coincidence proved to be nothing more than that.

On September 2, 1904, Arizona rangers captured and arrested a man identified as Charles Douglas following a desperate pistol duel that left him wounded. After being taken into custody and treated for his gunshot wound, the prisoner confessed to being Dunham. A resident from nearby Douglas, Arizona, who had once been acquainted with Dunham's father confirmed his identity. The prisoner then recanted his story and instead confessed to being an escaped convict. Further investigation revealed that the prisoner's real name was Robert Cook, an escapee from a nearby asylum for the insane. Mr. Cook, who came from a prominent family in Travis, Texas, had worked at a bank in Globe, Arizona, when he was thrown from a horse and suffered permanent brain damage.

More Changes in the Sheriff's Office

On February 21, 1905, Sheriff Langford died from a lingering illness. He was only fifty-three years old. His son Arthur actively sought the appointment to replace his father but received only one vote from the board of supervisors. Frank Ross was appointed to the position, and he graciously appointed Arthur as one of his deputies.

Ross was born in 1871 in Modesto, California. His father had come to California in 1852, settling in the San Joaquin Valley. When Ross was eleven, his family moved to San Jose. Frank attended public schools until he was fourteen years old, at which point he temporarily enrolled in the University of the Pacific until Stanford University opened. Finishing two semesters at Stanford, he enrolled at the San Jose Business College and received his business education. In 1892, he was promoted to the position of manager for the Mount Hamilton Stage Company, where he'd been working as a stagecoach driver since the age of sixteen. Ross later went to work for the Southern Pacific Depot, where he was in charge of the baggage room.

Ross was only thirty-two years old when he was sworn in as the sixteenth sheriff of Santa Clara County on February 28, 1905. Two months into his term, on April 28, Ross showed the public and his department that he was

a sheriff who led by example. A band of pickpockets boarded a train from San Francisco to Monterey. While on a stop in Palo Alto, the gang picked the pockets and purses of many local and prominent citizens. Sheriff Ross, upon being notified of the crimes, boarded the train on its return trip to San Francisco and easily apprehended two major leaders of the gang.

Later that same day, two stagecoaches were lumbering down from Mount Hamilton to San Jose. As the first stage neared Smith's Creek, a lone gunman held up the stage and robbed the passengers of their money and valuables. Minutes after sending the first stage on its way, the second stage rolled into the robber's sight. When word reached Ross, he instantly responded to the scene with a posse of deputy sheriffs. The very next day, the sheriff arrested the holdup man in Los Gatos.

On April 18, 1906, Sheriff Ross was awakened early by the great San Francisco earthquake and raced downtown in his automobile. He personally directed work and rescue parties downtown and at Agnews State Hospital, where hundreds of inmates were killed and injured.

Less than a month before the 1906 election, Ross received a report of an attempted robbery of Angelo Carbone, a vegetable peddler, by heavily armed highwaymen on Monterey Road, about two and a half miles south of San Jose. Carbone was returning from the Twelve Mile House with his team and delivery wagon when the bandits approached at about 6:45 p.m. on October 16. Carbone and his team managed to outrun the bandits and made it into San Jose, where he telephoned the Sheriff's Office and reported the crime. Ross and Deputy Cottle jumped in an automobile and set out to find the bandits. Less than two hours later, the outlaws were in jail awaiting arraignment the next morning.

In the November, Ross narrowly lost his reelection bid to Arthur Langford, son of the late former sheriff Robert Langford, by only 309 votes. The day Ross was to step down and turn the jail over to Langford, he filed an injunction contesting the election results. During the weeklong trial, the county actually had two official sheriffs. Sheriff Ross locked his deputies inside the jail, while Sheriff Langford handled matters outside the jail. On January 15, 1907, Judge Welch ruled against Ross. Langford took over as sheriff later the same day, becoming the seventeenth sheriff of Santa Clara County.

In 1907, Sheriff Arthur Langford was sued by a man named Frank O'Connell for false imprisonment. Mr. O'Connell had been arrested by two "outside deputies" on charges of stealing coal from the county. Although the charges were completely groundless, O'Connell was held in jail

overnight and pressured to identify individuals who had illegally influenced previous elections. With no evidence of any crime whatsoever committed by O'Connell, he was released from jail and subsequently filed suit against Langford. The matter was settled in 1908 when Langford made a statement in court that the deputies had arrested O'Connell without his knowledge or consent and instead had acted under the direction of a former district attorney. Langford also stated on the record that O'Connell was innocent of all charges levied against him.

WILLIAM HATFIELD GOES TO JAIL

n September 1908, a suspect named William Hatfield was apprehended in Sherman, Texas, by Deputy U.S. Marshal Lee McAfee. The marshal believed that Hatfield bore a resemblance to Dunham. Hatfield also had a birthmark that was said to match one that Dunham had.

Santa Clara County deputy sheriff Howard Buffington was often called on to validate the identity of suspects in custody around the country whom local authorities believed to be Dunham. He had gotten to know Dunham in Campbell while working at the McGlincy ranch. He had even been riding with Dunham on a tandem bicycle the night before the murders.

Buffington accompanied Sheriff Langford to Sherman, and after spending time with the prisoner, he determined that Hatfield was not Dunham. The deputy sheriff provided the following account of why he was well qualified to make such a determination:

> *I knew Dunham but slightly prior to his marriage to Hattie Wells, the stepdaughter of Colonel McGlincy, at Campbell, in 1894, but from that time on I saw Dunham very frequently.*
>
> *Jim Wells, Mrs. Dunham's brother and one of the victims, was a very close friend of mine. He lived at the McGlincy home and I was there a good share of the time. We called him "Kid Wells" and he was an athlete and expert bicycle rider.*
>
> *I was riding a good deal in those days myself and "Kid Wells" and I used to team together.*

Colonel McGlincy was a fine old man and the family was one of the most devoted I ever knew. After Jim Dunham married Miss Wells he came right into the family and his presence seemed to make no difference. I never heard of a word of trouble between Dunham and the other occupants of the house.

I remember very well when the Dunham baby was born how excited and happy all the folks were about it. That was only three weeks before the murder.

I used to work about the McGlincy ranch helping in the fruit. "Kid Wells" and I were together nearly all the time. Jim Dunham was going to school at Santa Clara College at this time. He was a queer kind of fellow. He would come home to the ranch where Wells and I were working and would stop and look at us merely passing the time of day. He never talked much and seldom entered into any of our fun.

About the time the Dunham baby was born "Kid Wells" and I bought a tandem bicycle. I was training for a road race and when the new wheel came my brother, Lloyd Buffington, Wells, and I went out to try it. Lloyd and Wells had the tandem and were making pace for me over a nice stretch of road near the Winchester place and we were going at a fast clip when the front forks of the tandem broke, throwing Lloyd and Wells.

Wells was badly hurt. He was just getting about on his feet again when the murder took place or there might have been another ending to the tragedy. Wells was strong as a bull, a thorough athlete when in condition and I don't believe Dunham would have got him that night if it had not been for his injuries.

After the tandem accident, I took the wheel into San Jose to have it fixed up. On the day of the murder I went into town to see if the repairs were finished and I met Jim Dunham at Osborn's bicycle store on South First Street. We were together for some time. I asked him if he was going out to Campbell for the night and he said he was going to stay with his mother in San Jose. I left him about six o'clock.

About an hour later Fran Sprung, a blacksmith in Santa Clara saw Dunham alight from a car at the end of the line and start toward Campbell. He was also seen later on the Dry Creek road by Robert Hamilton and that was the last seen of him before the murder.

Dunham's personality was out of the usual. I was a young fellow in those days, but I remember distinctly the impression he created on me. He had a way of looking straight at you when you were talking to him that made you nervous.

Deputy Sheriff Howard Buffington (*left*) and his brother Lloyd (not shown) rode bicycles with Dunham days before the murders. Decades later, Buffington became a pivotal figure in two other crimes that captured national attention: the 1933 kidnapping and murder of Brooke Hart and the Lamson murder case that same year. This photo was taken during the Lamson murder trial. *Courtesy History San Jose.*

He seemed to be looking through you. There was a droop to the eyelids that intensified his expression. At the top of Dunham's nose there was a peculiar mark. I would call it a "dimple," just a little depression in the skin.

Kid Wells used to have charge of the Campbell irrigating ditch, and I worked on that sometimes with him. One night he asked a number of the boys to go up to the ditch for a swim and Dunham joined the crowd. We found a good swimming hole and went to it. When we were dressing, I happened to glance at Dunham's foot and said:

"For heaven's sake Jim, have you been trying to cut your toes off?"

Jim laughed and glanced down at his foot. "No," he said. "I cut myself with an ax while splitting wood."

There was a big scar on his foot just above the toes. It was on the left foot.

Dunham had a brother, Charley Dunham, and a sister, who was in the Normal School at the time of the murders. These and the baby girl were his only near relatives.

Several years after the murder they changed their names to Cobb. The little daughter died in San Jose of scarlet fever about four years ago.

At the Grayson County Jail, Buffington had picked Hatfield out of a lineup of about forty prisoners. He approached Hatfield and asked him point blank, "Do you remember me?" With a calm voice and steady gaze, Hatfield replied, "Never saw you before."

"Are you sure of this?" Buffington asked.

"Very sure," answered Hatfield.

Buffington then asked the prisoner about a scar on his foot. Hatfield told him that he had cut it with an axe when he was a boy. Next Buffington asked the man his age. When Hatfield said he wasn't sure of his age, Buffington said that he had heard that the prisoner had previously told authorities that he was in his twenties. "Surely you are older than that," Buffington pressed.

Hatfield responded by saying, "Maybe I am a little older than that, but I have done a great deal of hard work in my life and you know this makes a man look really older than he is."

"Yes, you look as though you are about 45," said Buffington.

"I know I am not that old. In fact I do not know just how old I am, but I know I am not that old," Hatfield replied.

Buffington then took the man to a corner of the room and spent about ten minutes in conversation with him. At no point in the discussion did Hatfield

volunteer where he had lived before or the name of anyone who could positively identify him as Bill Hatfield.

However, a Mrs. Zimmerman, who was a former neighbor of Dunham's in San Jose and who claimed to have known him well, was sure that the prisoner indeed was Dunham. Hatfield, other than denying he was Dunham and maintaining that he'd never been to California in his life, said little.

As news of Dunham's possible arrest in Texas reached the papers, public interest was high, and Santa Clara County sheriff's deputies were inundated with inquiries. According to one deputy who had been working at the jail that weekend, "Sunday the questioning increased in frequency and last night the jail office was visited every few minutes by interested parties who were not satisfied with communication by wire. There is no doubt but that Dunham is about the best advertised proposition in this part of the state."

When Undersheriff Bray was called out of town to attend to a sick relative in Oakland, he left word with Jailer Monahan that any developments in connection with the Dunham case would be "sub rosa." After looking up the meaning of the term, Monahan made sure that no information was furnished to news seekers. One afternoon, reporters had followed the messenger boy who delivered a telegraph to the sheriff's office. No amount of urging could get Monahan to reveal its contents. "It's sub rosa" was all he would volunteer.

Reporters finally caught a break when Santa Clara County district attorney Arthur Free released the contents of the message that Langford had sent:

September 28, 1908

BUFF SAYS WRONG MAN BUT RINGER; MANY STRANGE THINGS; SHALL I BRING HIM BACK TO SHOW PEOPLE; DO NOT LIKE TAKE ONE OPINION; MRS. ZIMMERMAN SAYS DUNHAM

Officials in both Texas and California were not convinced of Buffington's assessment. A flurry of letters and telegrams was exchanged between California governor James Gillett, District Attorney Arthur Free and U.S. Deputy Marshal McAfee that culminated in the governor ordering Hatfield brought to San Jose so that locals there could evaluate him.

Langford and Buffington returned to Sherman in October to escort Hatfield west. When they arrived, Sherman authorities initially refused to

give the prisoner up unless a $2,000 reward was paid, fostering a rumor that the birthmark had been painted on Hatfield and that Hatfield was a party to the scam. California governor James Gillett alerted DA Free that he would contact Texas governor Campbell and that he expected the prisoner to be dispatched to Langford in short order. Soon after, Hatfield was expedited to California.

As many as five thousand curiosity seekers came to jail to get a look at the suspected killer. About fifteen people, some of whom were prominent residents of the Santa Clara Valley, said the man was indeed Dunham. About one hundred others, however, said he was not Dunham. One of the doubters was ex-sheriff Bollinger, who declared that although there was a general resemblance, the two men had nothing in common with regard to physical features and personality.

Undeterred by the uncertainty, DA Free formally charged the man from Sherman with the McGlincy family murders on the afternoon of November 8, shortly after his arrival in San Jose. Free maintained that Hatfield had been unable to adequately account for his movements in the days leading up to the murders. The DA summoned about thirty witnesses to appear

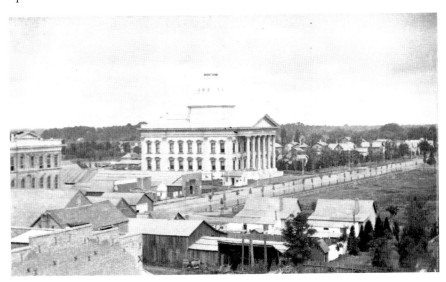

The Santa Clara County Courthouse and jail, where William Hatfield was incarcerated, was the scene of many famous trials. Tiburcio Vasquez, the notorious leader of a Wild West gang of train robbers, was convicted and executed for murder here in 1875. In 1933, an angry mob stormed the jail and lynched two men accused of kidnapping and murdering Brooke Hart, the popular son of the owner of Hart's Department Store. The Lamson murder trials were also held here in the 1930s, photo circa 1868. *Courtesy History San Jose.*

in court and testify as to the man's identity. Hatfield appeared in court unaccompanied by an attorney. The complaint was filed against James C. Dunham, even though the defendant told the court his name was Hatfield.

At 4:00 p.m. on November 11, 1908, two months after his arrest in Sherman, Texas, William Hatfield walked away from the county courthouse a free man, absolved of all suspicion of being James Dunham. U.S. Marshal McAfee of Sherman, on the other hand, was bitterly condemned for "deliberate misrepresentation."

Hatfield had entered the packed courtroom earlier that day appearing calm and self-possessed. In contrast with his arraignment proceedings, he now had legal representation. His lawyer, R.C. Parker, was a Fort Worth attorney who happened to be in town on other business and graciously volunteered to help out a stranger in need who had no friends. As Hatfield took his seat, a newspaperman shook his hand and asked him how he was feeling. "I'm alright," was the reply. "I realize that I am charged with a very serious crime, but being conscious of my innocence I am confident of the result."

DA Free began his line of prosecution by asking presiding justice F.B. Brown for permission to address the question of the defendant's identity before offering any testimony as to the facts of the crime. With the judge's consent, Free called W.A. Parkhurst to the stand. Parkhurst had been a resident of San Jose since 1859, had known Dunham since boyhood and had seen Dunham frequently over the years. He told the court that the prisoner was not Dunham. He explained that Dunham had short stubby thumbs that were very different from the defendant's, as well as a different-shaped nose. He also noted that Dunham was a "quick, nervous man," whereas the defendant might be called "a slouch."

Next up was a Dr. Cooper, a Campbell resident of eighteen years who had seen Dunham four or five times. "I think I would recognize Dunham. The prisoner is not Dunham. I base my opinion on the shape of his face; the nose, chin, and forehead are different; this man's nose is not as flat as Dunham's and his forehead recedes too quickly."

Cooper's testimony was followed by that of attorney W.H. Johnson, who had known Dunham for a year and had seen him about twenty times over that period. When asked directly by Free if the defendant was Dunham, Johnson was elusive. He began by describing the peculiarities of both men, noting that other than two missing teeth and different-colored hair, the two men had identical features. He added, "I will not say conclusively that the prisoner is Dunham, but I believe the prisoner is James C. Dunham."

Later in his testimony, when Free asked the prisoner to walk across the courtroom so that Johnson could take a closer look, Johnson seemed to hedge his earlier statement. "That is not the walk of Dunham," he told the court. "He walked sprier than that."

D.J. Flannery, who had once had a fistfight with Dunham when they were schoolmates, said that although the prisoner had a strong resemblance to Dunham, the prisoner's facial expression, hair, voice, weight and walk were all different.

Charles Quincy was another boyhood friend of Dunham's who was with him when he injured his foot. He had never actually seen a scar on Dunham's foot but observed that the scar on the prisoner's foot had the same shape and was in the same location as the slit in Dunham's shoe that was made at the time of the injury. Nevertheless, he concluded his testimony by telling the court, "Judging from the general appearance of the prisoner I do not think he is Dunham. Dunham would be about 45 years old. I judge this man to be about 40."

Eugene Don was the Santa Clara County postmaster. "I saw Dunham the day before the crime was committed and saw him several times. I waited on him in a store. I do not think the defendant is Dunham, judging from general appearances."

George Theuerkauf, who employed Dunham twenty years earlier and would see him occasionally after that, said, "I do not see a single feature about this man that looks like Dunham. I could recognize Dunham forty years from now. This man does not look any more like Dunham than I do."

Theuerkauf's wife also testified. "James Dunham lived with our family for three years, about eight years before the crime. I saw him on the street a few days before that. I think I would know Dunham. The prisoner is not the man."

Ed Gilman testified, "I knew Dunham well. This man is not Dunham— his head is shaped different. I look as much like Dunham as the defendant does."

W.A. Menefee testified that Dunham frequently came to his ranch on the Arroyo Honda to hunt and fish. "There is no similarity between this man and Dunham…the pictures look alike, but the two men do not look alike… pictures often show no resemblance to the original."

A. Fatjo attended Santa Clara College with Dunham when the crime occurred. "This man's eyes, ears, nose hair and chin are different. Dunham had more the appearance of a professional man and this party has the appearance of a laborer."

George Whitney, a Campbell carpenter, had seen Dunham on the Sunday before the crime and had known him for a year. "This is not Dunham. I judge from general features. The shape of the mustache is similar but Dunham's was darker. Dunham's hair was gray and darker."

Mrs. E. Hill, a grocer to the Dunham family, noted, "I kept a grocery store on Orchard Street and knew the Dunham family in a business way. This man does not look to me like Dunham, no more than I do. I can't say in any detail why, but they don't look at all alike."

J.H. Everett, a livestock dealer who knew Dunham and had seen him at the McGlincy home, said, "This man is not Dunham. He had heavy, coarse hair; the chin is different; Dunham had peculiar thumbs."

J.J. Toomey was a constable from Santa Clara who knew Dunham during his last term at Santa Clara College, just before he committed the crime, and added, "This man is not Dunham. At first there seemed to be a similarity, but the more you look at the men and notice his walk and talk, the more the similarity ceases."

Two of Dunham's former dentists provided forensic testimonies. Dr. J.W. Davey testified that his record book confirmed his personal recollection that he had treated Dunham's sixth-year anterior lower molar by inserting a platinum filling. He told the court, "The corresponding tooth of the defendant has a slight cavity, but one that has never been excavated. It is not possible the defendant is James C. Dunham."

After adjourning for lunch, more witnesses testified in the afternoon. Dr. W.A. Gaston, Dunham's primary dentist and who was well known in San Jose, had this to say: "About two weeks before Dunham committed the crime at Campbell, I filled a posterior proximal cavity in his left superior lateral incisor with gold. Before the tooth could be filled treatment for two or three weeks was necessary, and at times Dr. Wright administered the treatment. I filled the cavity, however, and placed amalgam fillings to the number of possibly seven in other of his teeth, but I do not remember how many."

Other afternoon witnesses included Superior Judge P.F. Gosbey, who went to school with Dunham; George Cottle, a former deputy sheriff who knew Dunham from childhood growing up in the Willows; Superior Judge Richards, who had business relations with the Dunham family; Robert Anderson, a detective who knew Dunham; and Deputy Sheriff Howard Buffington, the former neighbor and one-time friend of the killer. All of them testified definitively and without qualification that the defendant was not Dunham.

Dr. W.A. Gaston (*center*) was Dunham's dentist. This photo was taken in 1910 at the Observatory Parlor Barbeque at Blackberry Farm on Mount Hamilton. *Courtesy History San Jose.*

After the last witness testified, Hatfield, with the consent of his attorney, took the stand. DA Free's line of questioning attempted to establish where he had been at the time of the murders, but it quickly became apparent that Hatfield would not be forthcoming and that the effort to establish his tracks from thirteen years earlier would take days. His attorney objected to further questioning, and he was excused from the stand.

At that point, Free moved to have the case dismissed. Justice Brown dismissed the case without hesitation, noting that the attempt to prove Hatfield was Dunham was a complete failure. He praised the District Attorney's Office and the Sheriff's Office, stating that they "possibly worked harder in an effort to shed light on this case than they were called upon to do."

Hatfield, who had plans to be a vaudeville performer, shook hands with the judge after the trial. Justice Brown in turn requested the district attorney and Hatfield's attorney, Parker, to ensure that the innocent man received his just due when he signed a contract with a vaudeville company. The Jose Theater engaged Hatfield to perform the following week.

Upon realizing that the prosecution had been misled about Hatfield's identify by a U.S. marshal in Texas, District Attorney Arthur Free of Santa Clara County reversed course and dismissed the charges. This photo was taken at the San Jose Gun Club sometime between 1900 and 1910. *Courtesy History San Jose.*

As he exited the courthouse, Hatfield spoke briefly with reporters, telling them he was pleased with his treatment in California and hinting that he might file damage suits when he returned to Texas. He then strolled through the city, attracting curiosity everywhere he went. Strangers gave him cigars, and the local restaurants gave him extra attention.

Free and Buffington, meanwhile, blasted U.S. Marshal McAfee after the trial for, among other things, blatantly lying about the existence of a scar on Hatfield's foot. When the Sheriff's Office had been told by one of his acquaintances of a large birthmark on Dunham's stomach about four inches to the right of the navel, Free had wired McAfee asking if Hatfield had such a mark. McAfee wired back, affirming Hatfield had a mark in the same place, although not as large. It was largely based on this information, which had been shared with the governor of California, that Hatfield was ordered to be brought to San Jose by the governor. A careful inspection upon his arrival revealed no mark or scar of any kind.

HOPE FADES

THE BLACK HAND

Dunham's criminal legacy inspired bounty hunters, adventure seekers and publicity hounds. However, it also inspired would-be copycat criminals. On the morning of August 17, 1909, a Mrs. Malato, who lived at 904 Locust Street in San Jose, received an illiterate, handwritten letter peppered with blotches of ink and signed "Black Hand." The letter did not ask for money or issue any threats. It simply informed Mrs. Malato that her son and the rest of her family would soon die in the same fashion that ended the lives of the McGlincy family. Enclosed with the letter was a piece of black ribbon sewn in the shape of a cross, along with a card with the picture of his satanic majesty. The envelope was from the Elite restaurant in Watsonville, and the letterhead was from Hotel Hillsdale in Mountain View.

DUNHAM THE INSURRECTO?

In June 1911, another Dunham sighting was reported in Tijuana. James Manlon, a San Jose resident and former Santa Clara College classmate of Dunham's, was visiting the border city when he claimed to have spotted Dunham among insurrecto forces. Manlon said when he approached the insurrecto and addressed him by the name of Dunham, he appeared visibly

startled; however, he made no attempt to deny that he was indeed Dunham. The two men spoke for several minutes, discussing the prospects of the insurrecto army.

The mysterious soldier of fortune told Manlon that he held the rank of sergeant and then abruptly changed the course of the conversation and began inquiring about various people who were prominent in Santa Clara County political life sixteen years earlier. Among those were San Jose chief of police Kidward, former district attorney Victor Shellar, former state senator Louis O'Neal and former politician Jim Rea. Manlon said the suspected fugitive was gray-haired and considerably thinner than when the two had been acquainted in San Jose and that he appeared tranquil and in no fear of capture by California authorities. Sheriff Langford, who by now had grown skeptical of most Dunham sightings, dismissed Manlon's story, finding it less than convincing.

A Message in a Jar

In July 1911, James Johnson and Joseph Schmidt were hunting on Pine Ridge near Madrone when they came across a closed jar that contained a note, written in pencil and signed by "Jim Dunham": "This is to certify that I am Jim Dunham, the murderer, of Santa Clara County. You will find my bones across the gulch in a cave. I gave you a good run, Sheriff. Good-by to my darling baby....You surely are a poor Sheriff. I could have shot you a number of times. You owe your life to me."

They turned the note over to Sheriff Langford, who observed that the handwriting closely matched samples of Dunham. He believed that Dunham probably had written the note and placed it there in the hopes that it would be found by one of the many lawmen and bounty hunters scouring the area and mislead them.

The note in the jar brought the mystery of James Dunham's whereabouts no closer to closure. Like so many clues that came before it, the veracity of this one was met with considerable skepticism from many quarters. News of the finding revealed waning interest in the case among the public and the press. The story received scant attention in the national press and was one of the last developments in the case to be reported on by any newspaper. The mystery of James Dunham remains unsolved to this day, but history is now conclusive for those who were touched by his ghastly deeds.

AFTERMATH

Disgraced Siblings

The weeks and months following the murder were difficult for Charles Dunham and his younger sister, Addie. Their parents had both died just a year earlier, and the siblings' only other relatives were an aunt, Mrs. Lydia May of Oakland, and an uncle, Mr. James C. Dunham of Rio Vista. Everyone in town knew the grisly details of the crime, and the story was kept alive by regular updates on the manhunt and rumors of James Dunham sightings across the country.

Charles and Addie were students at the State Normal School in 1896 and lived close to each other. He lived at 448 South Ninth Street and she at 444 South Tenth Street. Immediately following the murders, Charles sought refuge by spending his summer vacation at his late father's ranch near San Diego, while Addie stayed in town immersed in the voices of community outrage.

In October, Charles and Addie filed a petition in Superior Court to change their last name to Cobb, the maiden name of their grandmother. The petition stated that as because of "the shame, disgrace, and humiliation" brought to the family name by their brother James, they were being avoided by former friends and prevented from forming new friendships. Both were preparing to graduate from the Normal School the following month, and they felt that by abandoning the Dunham name, they would face less social

oppression and be less hindered in securing employment as teachers or engaging in any form of business. By adopting the name Cobb, the petition explained that "the odium and disgrace of said crime will be much sooner overcome and much sooner forgotten and overlooked by their present and future friends and acquaintances, than if the present name of petitioners is retained by them."

THE SEVENTH VICTIM

In November, Addie and Charles celebrated their graduation by attending a reception with their classmates at the residence of Principal Randall. That same month, Addie launched her career as a teacher at a school in the central California town of Hanford. When her identity became known, the shame she felt compelled her to return to San Jose. She subsequently moved to Santa Ana, but the same fate overshadowed her. She again returned to San Jose and soon landed a job at the Bernal Heights School in San Francisco.

For a time, Addie seemed to be adjusting to her new life in San Francisco, but the horror of her brother's crime weighed heavily on her. She struggled with depression and her health began to rapidly deteriorate. In September 1901, she returned to San Jose on a medical leave. In January 1902, she went back to her school in San Francisco, only to fall back into ill health and make a final return to San Jose three weeks later.

In May, she succumbed to illness and depression. The body of Adelaide "Addie" Margaret Dunham was laid to rest on May 30, 1902, at Oak Hill Cemetery on the seventh anniversary of her mother's death. Her death certificate ascribed the cause of death to consumption. The *Evening News* portrayed her death differently with this headline: "INNOCENT GIRL DIES FOR BROTHER'S CRIME—Sensitive Spirit of Infamous Slayer's Sister Is Stilled in Death's Embrace." Her obituary characterized her as "the seventh victim of James C. Dunham."

MINNIE SHESLER'S PARENTS

Minnie was the daughter of Dr. Jacob Shesler and his wife, Elizabeth. The couple lived nearby on Marliere (now Spencer) Street and Home (now

Virginia) and were well known in the community. Dr. Shesler was a native of Ohio who earned his medical degree from the Physio-Medical Institute of Cincinnati in 1878 before settling in San Jose, where they raised two daughters and a son.

At the request of her parents, Minnie's burial service was separate from that of the McGlincy family and Robert Brisco. Her funeral took place a day earlier, on May 28 at 1:30 p.m. under the auspices of the Kate Sherwood Camp, Daughters of Veterans.

The couple, who at the time of Minnie's death were aged and financially dependent on their daughter's income, filed a damage suit against Dunham for the loss of their daughter, asking for a sum of $25,000. In June 1897, a judgment for $8,000 was rendered against Dunham in favor of the Sheslers.

Dunham's $1,400 mortgage against the Penniman Fruit Company was to be levied to partially satisfy the judgment. However, Sheriff Lyndon refused to comply with the court's decision on the advice of his attorneys, who gave their opinion that the judgment in favor of the Sheslers was void because Dunham had not been served and because it could not be legally shown that Dunham was avoiding the law. Dr. Shesler responded by filing a suit against the sheriff requesting that he be forced to distribute the money to him. The trial in the case of *J. Shessler v. J.H. Lyndon* commenced on December 15. In February 1897, Judge Kittredge handed down a decision sustaining the contention of Shesler, and the sheriff was ordered to sell Dunham's securities and apply them to Shesler's award.

Shesler's victory was short-lived, however. In November 1901, after extensive appeals, the state Supreme Court reversed the entire $8,000 judgment, citing a lack of jurisdiction. Jacob died in 1907 at the age of seventy-four, and Elizabeth died in 1913 at the age of seventy. The couple went to their final resting places at Oak Hill Cemetery, heartbroken over the loss of their daughter and deprived of the restitution they sought from her killer.

The Orphan

In the days following the murders, guardianship of the Dunham's son, Percy Osborn Dunham, was awarded to the infant's grand-uncle, Michael Thomas Brewer of San Francisco. Mr. Brewer's wife, Harriet, was Ada's sister. With Dunham on the loose and considered extremely dangerous, the home was guarded by a police officer twenty-four hours a day.

The question of who was entitled to inherit the McGlincy estate and how it would apply to the care and long-term benefit of Percy was complex. One of the pivotal questions surrounded the killing sequence on the night of the murders.

Under prevailing laws of intestate succession, had the colonel been killed first, his wife, Ada, would have assumed rights of survivorship. Her children, James Wells and Hattie Wells-Dunham, would have been next in line, presumably with equal shares of the estate. In the absence of a will, it would be likely that Hattie would be beneficiary of her brother James's share of estate if he were to be struck with an untimely premature death. If Hattie were to have died first, her share would logically belong to her husband. And if James Dunham were to then die, it was assumed that their infant son would inherit the family fortune.

That assumption was called into question in June when San Francisco attorney George Dyer stopped off in Washington, D.C., on his way to New York to pay a visit to his old friend J.A. McDowell of the Coast Survey. The two men had become friends years earlier when they worked together in the mining business. News of the McGlincy murders had reached the D.C. papers, and as soon as they sat down, Mr. McDowell asked Dyer about the value of the McGlincy estate. He knew that Dyer had been once acquainted with McGlincy, and his interest was more than a passing curiosity.

When Dyer told McDowell that he thought the estate was valued at approximately $75,000 and that it would go to McGlincy's grandson, McDowell introduced a startling piece of information. Eva McGlincy, the colonel's forty-year-old sister, was employed by McDowell and, in fact, was working in an adjoining room while the two men talked. McDowell asserted that his employee, who had only learned of the killings through a brief newspaper story days earlier, should be the rightful heir to her brother's estate. Dyer readily agreed and immediately telegraphed a fellow San Francisco lawyer, E.L. Campbell, and retained him to act as Eva's attorney. For her part, Eva was surprised at the suggestion of an inheritance, but on the advice of her new attorney, she set out for California to file her claim.

It then came to light that before the murders, McGlincy had transferred ownership of nearly his entire estate, including the ranch, to his wife, Ada, who in turn had willed the bulk of her estate to her son, James, and daughter, Hattie. With the death of Ada, James and Hattie, it was presumed that her estate, reported by the newspapers to be as much as $200,000, reverted to the killer himself. However, with Dunham on the lam, and with hanging or a lynching certainty if he ever were to be captured, the child was the logical

heir apparent. Indeed, there was compelling reason to believe that Dunham had planned his crime with that outcome in mind.

Eva's lawyer noted that because Ada was killed first, Colonel McGlincy became the surviving spouse, albeit for a very short period of time, and under the law, he was heir to half his wife's estate. It was further asserted that upon the colonel's death moments later, his sister, Miss Eva McGlincy, as his next of kin, was the sole heir to her brother's estate. Ultimately, the court ruled against Eva, rendering her trip to California fruitless.

With Percy as the sole heir to the estate, the question of estate administration and Percy's guardianship fell in the hands of the courts. Eventually, a family friend, E.N. Carr, became the designated executor, and Brewer became Percy's guardian. As part of the arrangement, Carr was to pay Mr. Brewer the sum of fifty dollars per month as an allowance for Percy's support.

The matter became even more complicated in October 1896 when Mr. Brewer's wife filed for divorce after thirty years of marriage on grounds of his failure to provide. Although Mrs. Brewer had allowed her husband to be appointed guardian of her sister's grandchild, as part of the divorce proceeding, she sought custody of the child for herself. Apparently, the divorce proceedings were dropped, and in October 1898, Mr. Brewer successfully filed a petition to have the estate under his control for the benefit of the child.

Two months later, Mr. Brewer passed away from a kidney disorder (uremia) at the age of sixty, leaving behind his wife and family in San Francisco. Mrs. Brewer assumed her husband's responsibilities as guardian and financial steward for Percy. Having sufficient cash on hand to pay expenses on behalf of Percy was a daily challenge. Although the estate was estimated by various sources to be worth between $75,000 and $200,000, most of the valuation was tied up in the ranch property. The small amount of liquidity maintained by the estate was used to fund daily ranch operations. At that point in time, the ranch was struggling to avoid operating losses.

Mrs. Brewer addressed the situation by borrowing, using the ranch assets as collateral. In May 1899, an Edward Clayton, guardian of a minor named Ivan Treadwell, petitioned the probate court to loan $7,600 belonging to his ward to Mrs. Brewer at 8 percent annual interest. The loan would be secured by the old McGlincy ranch. The financial outlook for the ranch gradually began to improve, and by April 1902, when Mrs. Brewer filed the first annual account of the estate with the probate court, ranch revenues were $17,918 and expenses were $17,583. The filing promised more favorable returns in the future. With the sustainable

financial stability of the estate established, Mrs. Brewer was able to raise her nephew comfortably in San Francisco.

Ultimately, Percy assumed ownership of the ranch but never lived there. He died in Daytona Beach, Florida, on April 15, 1969. History is silent on the question of whether he ever learned of his biological father's identity or of his gruesome crime. What is known is that on his 1956 Social Security application, he listed his great-uncle, Michael T. Brewer, as his father and his mother as Hattie Wells.

History is left to ponder two questions. Does the fact that he identified his real mother, using her maiden name rather than her married name, suggest that his father's identity was never revealed to him? Or does it suggest that he knew and simply chose to erase any documented association with the evil killer who was his biological father?

THE FUGITIVE

James Dunham was never found, leaving crime historians to ponder theories of his escape. Some believe that he died in the hills. Undersheriff Hugh DeLacy, son of a former Santa Clara County sheriff, laid out the case in a December 1922 newspaper interview:

> *I firmly believe that the bones of James Dunham would be found in the thick brush of Indian Gulch back of Smith's Creek if adequate search were made. Dunham was last seen at Smith's Creek. Soon after he left there, a shot was heard. His riderless horse was found nearby. They have never discovered who fired that shot. I believe that Dunham fired it, that he killed himself and that the searchers simply failed to find his body.*
>
> *I'm sure I don't see what else there was for the man to do when he came to the realization of his crime. He certainly had nothing to live for. I'm convinced the man was insane when he did it, for only a crazy man could have done such a thing.*

DeLacy acknowledged that searches of the area came up empty but remained convinced that the killer's bones were still in the hills. "But I don't think the search was thorough, and although other searches have been made since, I don't believe any of them have been thorough enough to establish positively the fact that the body was not there. The brush is very dense there.

Today, all that remains of the McGlincy ranch is a street name. McGlincy Lane is populated by light industrial buildings and residences. *Author's collection.*

A search would have to be very thorough indeed to cover every bit of ground. And if such a search is ever made, I believe the mystery will be solved."

The undersheriff had specific thoughts on how such a search should be conducted: "It should be done the way they do such things in the army. Men should be stationed all around the gulch at not farther than ten feet apart. They should close in upon it, leaving no square foot of ground unsearched. Some people have been satisfied that a thorough search has been made, but until they have done it after this detailed manner, I will never be convinced that Dunham did not commit suicide the morning after the crime and that his body is not still in Indian Gulch."

The last reported discovery of bones possibly belonging to Dunham occurred on Mount Hamilton in 1953. Investigators concluded that they were cattle bones.

Juan Edson believed that Dunham reached Tres Pinos and from there went to Mexico, traveling either along the coast or through the San Joaquin Valley to Ventura. The Mexico theory is entirely possible. Reaching the coast or the Central Valley from Tres Pinos would not have been terribly difficult. Yet no compelling evidence has ever surfaced proving the existence of the fugitive in Mexico.

If Dunham had made it to Mexico or anywhere else, he would have died of old age decades before the close of the twentieth century. Those of us who ponder his fate are left with only one certainty: Dead men tell no tales.

BIBLIOGRAPHY

Newspapers

Aberdeen Daily News. 1896.
Adrian Daily Telegram. 1896.
Birmingham Age-Herald. 1898.
Boise Statesman. 1896.
Butte Weekly Miner. 1901.
Campbell Interurban Press. 1908.
Campbell Weekly Visitor. 1896.
Canton Repository. 1898.
Charleston Evening Post. 1896.
Cincinnati Daily Gazette. 1878.
Daily Illinois State Journal. 1883, 1885.
Dallas Morning News. 1908.
Denver Post. 1896.
Denver Rocky Mountain News. 1901.
Elgin Illinois Daily Inter-Ocean. 1874, 1881.
Fresno Republican. 1891, 1893, 1896, 1908.
Grand Forks Daily Herald. 1896.
Jackson Citizen. 1896.
Kalamazoo Gazette. 1897.
Knoxville Daily Journal and Tribune. 1896.
New York Herald. 1898.
Omaha World Herald. 1896.

Philadelphia Inquirer. 1896.
Riverside Morning Enterprise. 1899, 1904.
Riverside Press and Horticulturalist. 1899.
Rockford Daily Register. 1887, 1901.
Rockford Journal. 1878, 1880–81.
Rockford Morning Star. 1898.
Rockford Weekly Gazette. 1876–78, 1880.
Sacramento Bee. 1896.
San Diego Sun. 1893.
San Diego Tribune. 1896, 1906, 1908, 1934.
San Diego Union. 1893–98, 1904, 1911, 1934.
San Francisco Bulletin. 1874, 1877, 1885.
San Francisco Call. 1896.
San Francisco Chronicle. 1885, 1893–94, 1896–99, 1901–2, 1904, 1908, 1910, 1913, 1936.
San Jose Evening News. 1884–87, 1890, 1891–1905, 1907–13, 1915–19, 1921.
San Jose Mercury. 1896–97, 1906–8, 1911, 1913, 1914, 1915–18, 1920–22.
San Luis Obispo Telegram. 1910–11, 1939, 1943, 1946.
Springfield Republican. 1896.
Tacoma Daily News. 1896.
Vansville Courier. 1896.
Wisconsin State Journal, 1883–84, 1886.

Websites

All About Forensic Psychology. http://www.all-about-forensic-psychology.com/psychopath.html.
Chivers, Tom. "Psychopaths: How Can You Spot One?" *Telegraph,* April 6, 2014. http://www.telegraph.co.uk/tv/2017/04/20/psychopaths-can-spot-one.
Hare, Robert D. "Psychopathy and Antisocial Personality Disorder: A Case of Diagnostic Confusion." Psychiatric Times, February 1, 1996. http://www.psychiatrictimes.com/antisocial-personality-disorder/psychopathy-and-antisocial-personality-disorder-case-diagnostic-confusion.

INDEX

A

Ackerman, Fred 42
Agnews State Hospital 10, 80, 98
Ainsley cannery 7
Allen, Augustus 78
Alum Rock 69, 85

B

Ballou, Stephen 47, 50, 56, 64, 67
Bank of Campbell 7
Belloli, J.A. 38
Bollinger, George 59, 64, 105
Branham, Ben 27, 29, 61
Brewer, George 37
Brewer, Harriet 117, 119
Brewer, Michael 117, 119
Brewer, Percy 117, 118, 120
Brisco, Robert 12, 16, 41, 117
Budd, James 47
Buffington, Howard 100, 111

C

Campbell, Benjamin and Mary 7
Campbell Fruit Growers Union 7

Christian Endeavor Society 29
Citizens Executive Committee 85
Coe ranch 67
Congregational Church at Campbell
 29
Cottle, George 71, 76, 98, 108
Crill, Charles 86, 89, 90

D

DeLacy, Hugh 59, 120
Delmas Avenue 35
Dry Creek 49
Dulzera 33, 42, 44, 83, 95
Dunham, Addie 115
Dunham, Charles 32, 43, 44, 115, 116
Dunham, Hattie 12, 32, 34, 36, 41, 45,
 100, 118, 120
Dunham, Isaac 42, 44
Dunham, James 12, 14, 17, 20, 32, 33,
 34, 35, 36, 38, 42, 43, 44, 45,
 46, 49, 50, 54, 59, 64, 72, 74,
 76, 79, 81, 83, 85, 86, 87, 91,
 93, 94, 95, 96, 100, 106, 107,
 108, 113, 115, 116, 118, 120
Dunham, Kate 42, 43, 44

E

Edson, Juan 59, 69, 70, 71, 92, 122
 background 64
El Dorado Street 64
El Renegado 94

F

Fellows, Dick 59
First Christian Church 29
Foxworthy Road 33
Free, Arthur 104, 106, 109, 111
funeral services 29, 30, 31

G

Gage, Henry 61, 80
Gardener, Mattie 43
Gaston, W.A. 82, 108
Good Government League 78
Goss, John 37
Grant ranch 85
Grape Growers Protective Association 13
Guilkey, Roy 38

H

Haskell, Dan 60
Haskell, N.A. 30, 42
Hatfield, William 100, 103, 104, 106, 109, 111
Heinlenville 62
Herrington, Bert 42, 64
Hyde cannery 7

I

Infirmary Road 17
Insurrecto 112

J

James, Dietta 95
Johnson, W.H. 106
Jones, Clinton 81

K

Kate B. Sherwood Camp, Daughters of Veterans 29
Keeler, Fred 81
Kenna, Robert 34
Kidward, Jason 74, 76, 85, 113
Kirkpatrick, W.J. 40

L

Langford, Arthur 98, 100, 104, 113
Langford, Robert 78, 79, 80, 82, 83, 86, 87, 91, 95, 97
Lick, James 53
Lick Observatory 77
Luis, Ramon 60
Lyndon, James 11, 14, 18, 47, 56, 65, 67, 69, 76, 77, 78, 79, 117

M

Manlon, James 112
McGlincy, Ada 12, 13, 35, 37, 41, 117, 118
McGlincy, Eva 118, 119
McGlincy, Richard P. 12, 14, 16, 34, 41, 101, 118, 119
McIlrath ranch 67, 68
Mexico 36, 59, 61, 71, 76, 77
Miller, Henry 43, 50, 87
Monterey Road 30, 81, 98
Morrow ranch 53, 69
Mount Hamilton 50, 56, 68, 77, 93, 97, 122

N

New Almaden 29, 60
North Market Street 29

O

Oak Hill Cemetery 30, 116, 117
Odd Fellows 29

Orchard City 7
Osgood & Smith Cyclery 38, 68

P

Pacheco, Inez 29
Pacheco Pass 81
Pacheco, Pedro 28
Parker, H.M. 36
Parker, Oscar 53, 64, 67, 69
Penniman, A.C. 37

Q

Quincy, Charles 33, 107

R

Ross, Frank 97
Ross, L.C. 17

S

San Felipe Valley 67
San Fernando Street 38
San Francisco Call 20, 24, 38
San Jose Grange 30
San Jose High School 45
San Pedro Street 64
San Quentin State Prison 28
Santa Clara College 34, 45, 101, 107, 112
Santa Clara County 25
Schaeble, George 16, 35, 43
Second Street 43
Shesler, Elizabeth 116
Shesler, Jacob 116
Shesler, Minnie 12, 14, 35, 41
Smith's Creek Hotel 50, 56, 64, 65
Snell, Everett 53, 56, 67
Snell, Thomas 53
South First Street 38
South Third Street 38
State Normal School 33, 115
Sterret, Charles 17
Sweigert, Jonathan 29

T

Tennant, Fred 78

V

Vasquez, Tiburcio 59

W

Wadams, Wood 69
Waseliege, John 61
Wells, James 12, 14, 16, 34, 37, 40, 41, 65, 100, 118
Willow Street 30

ABOUT THE AUTHOR

A s a teenager, Tobin Gilman spent weekends performing landscape maintenance at a building owned by his father. The building was located at the corner of McGlincy Avenue and Union in Campbell, California. At the time, he was unaware of the grisly crime that had occurred in the vicinity more than a century earlier. Tobin has spent more than thirty years as a marketing professional in the Information Technology industry, and his hobbies include antique bottle collecting, motorcycling and shooting sporting clays. He is the author of *19th Century San Jose in a Bottle*, a book about daily life and commerce in his hometown during the 1800s, told through the prism of glass bottles used by local druggists, breweries and purveyors of mineral waters, soda, distilled spirits and food products of the day.